watercolor
BY DESIGN

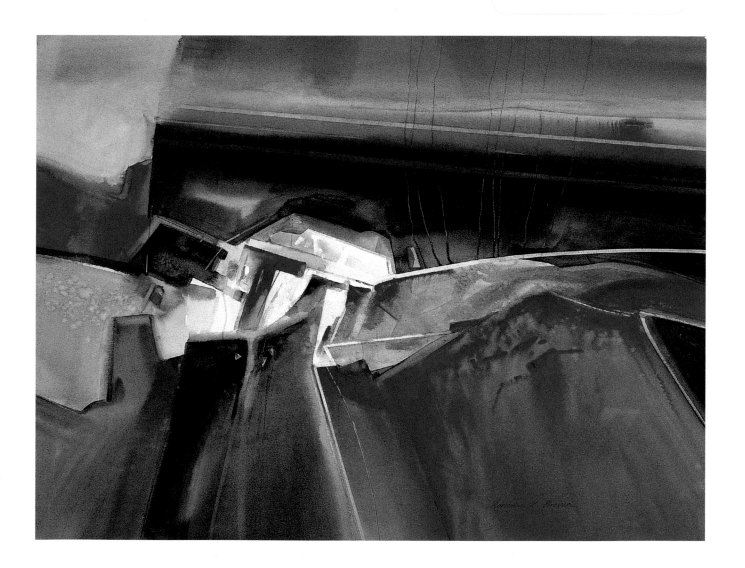

watercolor
BY DESIGN

CLASSIC DESIGNS
TO INSPIRE
NEW CREATIVE
DIRECTIONS

MARIANNE K. BROWN

WATSON-GUPTILL PUBLICATIONS
NEW YORK

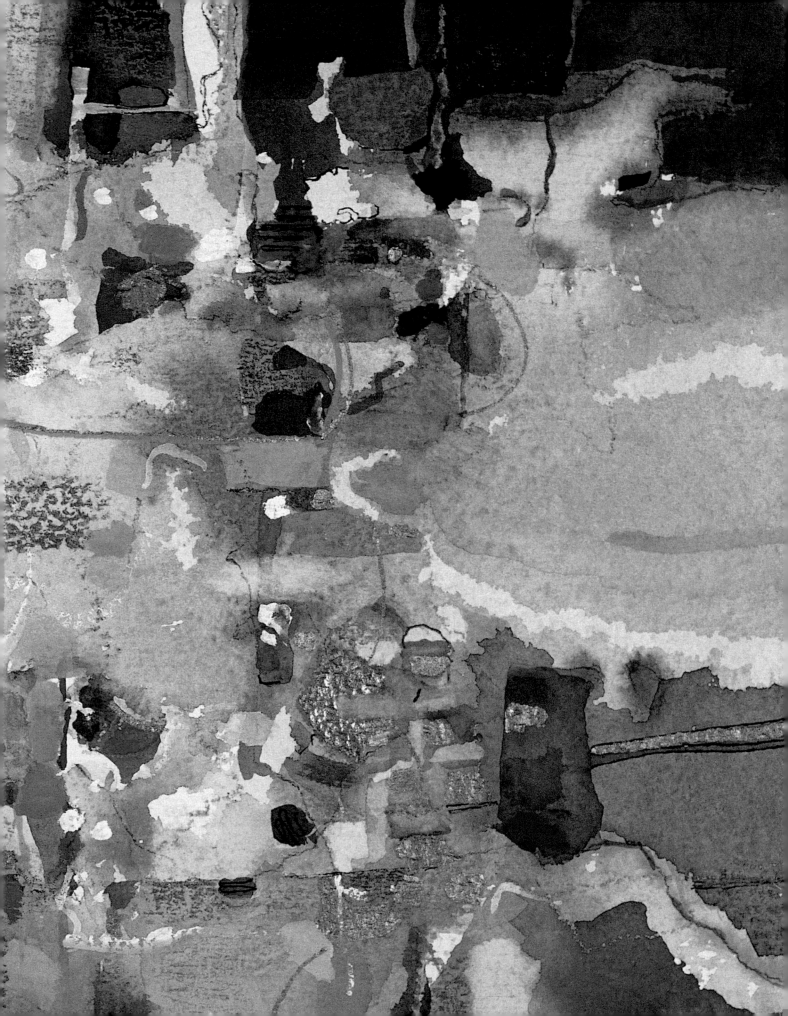

FRONT COVER
Marianne K. Brown, CITY PARK (DETAIL), watercolor and salt on paper, 11 × 15" (28 × 38 cm).

FRONTISPIECE
Marianne K. Brown, BIG SUR, watercolor on paper, 22 × 30" (56 × 76 cm).

TITLE SPREAD
Marianne K. Brown, SYLVITE, watercolor on paper, 11 × 15" (28 × 38 cm).

Senior Acquisitions Editor: Candace Raney
Project Editor: Robbie Capp
Designer: Areta Buk
Graphic Production Manager: Hector Campbell

Text set in 11.75-pt. Perpetua

First published in 2006 in the United States by Watson-Guptill Publications,
a division of VNU Business Media, Inc.
770 Broadway, New York, NY 10003
www.watsonguptill.com

Library of Congress Control Number 2005937102
ISBN: 0-8230-5995-2

Printed in Singapore

First printing 2006

1 2 3 4 5 6 7 8 9 / 14 13 12 11 10 9 8 7 6

acknowledgments

Many thanks to my students, whose enthusiasm and perseverance hardly ever faltered through the decades as we discussed, constructed, and painted, using the ideas and procedures for the basic designs found in this book. I also owe thanks to my proofreaders for their help in putting my words into a readable manuscript; to my friends, for their encouragement and aid with computer problems and photography; to my family, who allowed time for me to write and planned frequent outings to get me away from the studio and into interesting restaurants; and to the seasoned professionals at Watson-Guptill—Candace Raney, senior acquisitions editor; Robbie Capp, project editor; Areta Buk, designer; and Hector Campbell, production manager—for guiding this book to print.

about the author

Marianne (Kircher) Brown, who holds a B.S. degree in art education from the University of Wisconsin, and an M.A. degree in fine art from the University of Arizona, has been teaching adult education classes in watercolor techniques and design for more than thirty years. She is a signature member of the California Watercolor Association, the National Watercolor Society, and the Society of Experimental Artists, where she received the Nautilus Fellowship in 1999. Her work has appeared in *Watercolor Magic, International Artist,* and *Palette* magazines, and in many books, including *Abstracts in Watercolor* (1996), *Best in Watercolor* (1997 and 1998 editions), and *Splash 8* (2004). She and her husband live in Moraga, California.

contents

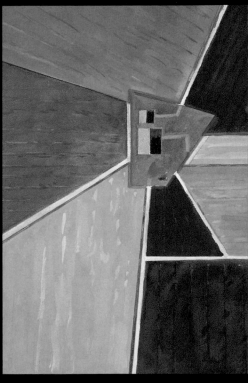

introduction

This book presents painting techniques and basic design motifs that can help you organize and execute your paintings. I have used these principles in teaching adult watercolor classes for thirty years, and the results have been highly satisfactory. Paintings by my students have been in art exhibits, have received awards, and have been published in art books. It is my hope that you will experience equal success with your watercolor art based on the new creative directions presented here.

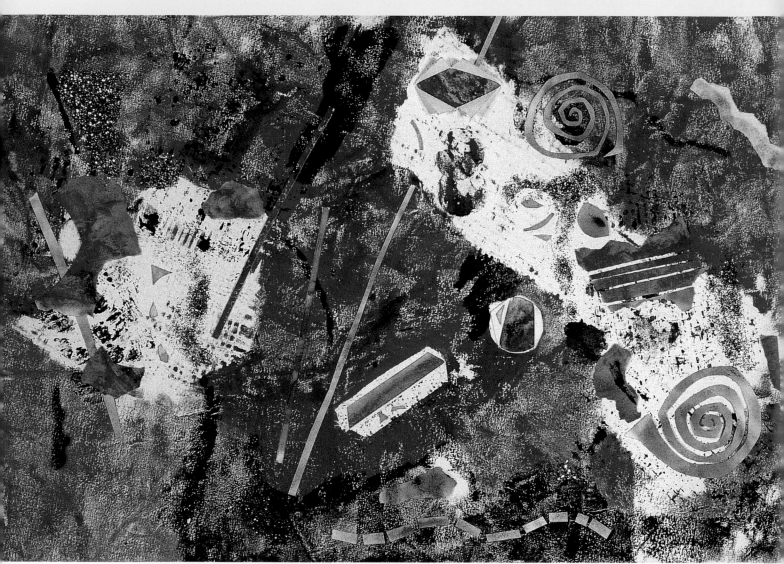

Kathy Collop, MISCHIEF, watercolor monotype and collage on paper, 15 × 22" (38 × 56 cm).
The pyramidal form fashioned by the edges of the white shapes and dark line displays the triangular path of the design. Without Kathy's carefully worked-out structure, this painting could have been just a jumble.

In putting my ideas together for this book, I photographed the work of more than eighty students. Many of their paintings appear in these pages as examples of diverse approaches to basic design schemes. Design is the structural element of the creative process. When creativity and structural control combine in paintings, the results are wonderful. If you know how to use the basic divisions of shapes and space, good compositional choices occur automatically. And although this book focuses on watercolor, all of the design instructions are effective for planning artwork in virtually any medium.

TWELVE CLASSIC DESIGN MOTIFS

The chapters that open this book—"Materials," "Fundamentals," "Preliminary Drawing," and "Color Review"—are followed by chapters that present twelve basic design motifs to be used in planning innovative, creative, and personal arrangements of spaces, colors, and shapes in your paintings. Some of the design schemes are familiar ones; others may be brand-new approaches for you to try. Build on your understanding of design structures by working with the twelve design chapters.

Each chapter begins with an overview, then goes to a step-by-step demonstration. Many possible arrangements and ways to develop unique compositions by using collage or drawings are included. Supplementary information and valuable tips are offered throughout. The chapters conclude with a gallery of paintings showing a variety of personal approaches to each design motif.

It is much easier to start a painting with an aim in mind than to discover a subject or direction as you paint. Choose your subject matter before you work out your design plan. This process becomes an exciting experience as you see what happens when you arrange and rearrange the shapes, colors, values, texture, and lines that make up your painting. Studying the designs will provide you with a foundation for planning interesting shape arrangements in your paintings. You can then go on to combine designs or to build your own compositions. This is true for artists who paint realistic subjects as well as for those whose style is abstract or nonobjective.

By exploring the broad range of design motifs and the possibilities for creative innovation offered by them, your work can be more stimulating and rewarding. Keep painting!

materials

You will find a list of supplies included with each demonstration. This chapter presents a general overview of those materials and any other items that may be mentioned in supplementary tips throughout the book.

WATERCOLOR PAINTS

Watercolors that come in tubes are used in all the paintings in this book. Of the many brands marketed widely, I usually choose various colors by Da Vinci, Grumbacher, Daniel Smith, and Winsor & Newton.

Watercolor paints have various pigment qualities: transparent, opaque, staining, or sedimentary. Manufacturers' color lists often include a letter indicating the pigment type: *T* for *transparent*; *O* for *opaque*; and *S* for *staining*.

Transparent pigments can be lifted easily and glazed successfully without damaging or staining the colors underneath. **Opaque** pigments obscure dry colors beneath them when used full strength, and allow little or no paper to show through. When used with more water as a glaze, they can blend or granulate on rough watercolor paper. **Staining** colors are labeled *phthalo, thalo,* or *Winsor* for the Winsor & Newton brand. They stain the paper and any color underneath and cannot be lifted easily. They are best applied as first washes; when dry, other colors can be glazed on top of them. **Sedimentary** colors leave bits of finely ground pigment in water; instead of dissolving, they settle on the bottom of a water container. These same sediments will often embed in the texture of rough watercolor paper, resulting in what is called *granulation.*

Some watercolor paints have dual qualities, such as the **opaque-staining** or the **transparent-staining** colors. Contact paint manufacturers for their lists of color-pigment qualities. For further information, check the lightfast quality of the paints you buy; lightfast symbols appear on paint tubes and may be listed in catalogues.

OPPOSITE Miriam Hughes, VIEW FROM ABOVE, watercolor and pastel on paper, 22 1/2 × 19 1/2" (57 × 50 cm). This is a carefully arranged staggered-grid design structure. Miriam sketched the setup first and added a bit of oil pastel, which acts as a resist to the watercolor in the area of the brush bristles, towel, and parts of the palette. She finished by painting directly with washes and varied brushstrokes.

RELATED WATER-BASED PAINTS

Gouache is an opaque water-based paint that dries to a matte finish. It can be combined with transparent watercolor as a technique. Water-based **acrylics** can be applied with the same light washes as watercolors and glazed over one another easily when the first color is dry. They dry with a hard plastic finish.

PAPER

Watercolor paper can be purchased in various sizes, weights, and forms: individual sheets, blocks, or pads. In terms of texture, the three types are **rough** (the most grainy texture); **cold-pressed** (which has a less-pronounced grain and is the type used most often in the demonstrations and other paintings in this book); and **hot-pressed** (which has a very smooth surface).

The brand and weight of paper that I usually choose is Arches 140 lb cold-pressed, because it is best suited to both experimental and standard techniques. Other popular brands to consider are Fabriano, Saunders, and Lanaquarelle.

Additional papers to have on hand are: inexpensive **drawing paper** and/or **newsprint** (for preliminary sketches); **tracing paper** (for transferring sketches to watercolor paper); and **construction paper** (in various colors for planning shapes).

BRUSHES

The many available styles of watercolor brushes divide into two basic shape categories: rounds and flats. **Round** brushes have good points and fit nicely into corners. **Flat** brushes are best for broad washes and straight-sided shapes.

The "Supplies" list with each demonstration identifies the sizes and styles of brushes used. Professional-grade brushes made of sable hair are the most expensive, but more economical synthetic brushes work well and are widely available. Some brands to consider are Golden Fleece, Grumbacher, Robert Simmons, Da Vinci, and Winsor & Newton.

PENCILS, PENS

Drawing pencils are numbered according to hardness or softness: 8B to 2B are soft leads for making good darks; 2H to 8H are harder leads for making light, exact lines. Derwent makes a drawing pencil that blends into watercolor washes when wet, labeled with the value of the wash it produces; **charcoal pencils** may also blend into watercolor washes. A **carpenter's pencil** has a broad, flat-pointed lead that offers both a wide and narrow edge for sketching. Also take advantage of **colored pencils.** Some have an oil or wax base and repel watercolor washes. **Watercolor pencils** melt into watercolor washes. The colors are very close to tube paint colors, and are useful for adding accents or lines to a painting. The **Sharpie pen** is good for sketching and for going over the pencil lines on your sketch in order to see the drawing more clearly through your watercolor paper; and an adjustable **ruling pen** is a tool that can be used with watercolor paint or masking fluid as well as with ink for making lines.

MASKING TAPE, MASKING FLUID, GLUE

When you want to have your paper remain white in some areas, there are two ways to reserve, or block, paint from getting on your paper: use masking tape or masking fluid. **Masking tape** or **plastic striping tape,** both made by 3M in various widths, are safe choices, as they won't damage the paper when removed. **Masking fluid** serves the same purpose. The Winsor & Newton brand comes in two types: one has a yellow tint that may stain the paper if left too long; the other is **Colorless Art Masking Fluid,** and looks white on paper. **Yes** and **Elmer's Glue All** are two brands of glue that I use for collage work.

OTHER TOOLS

A **hair dryer** comes in handy if you want to speed the drying process. I also recommend always warming masking tape with a hair dryer on low before lifting it from your paper. If you have a **light box,** it will be a big help when it comes to seeing and tracing drawings down on your watercolor paper.

OPPOSITE **Randa Diamond, MOOD DESIGN,** watercolor on paper, 15 × 11" (38 × 28 cm).
Before painting, Randa blocked out the white area of her vertical-bar design with Winsor & Newton permanent masking fluid. When it was dry, she applied the light background wash. Then she added the darker values of color for contrast, and placed plastic bubble wrap on her wet paint to create the texture at upper left.

Marianne K. Brown

fundamentals

Since many of the design patterns in this book are based on using a grid for their structure, one basic preparation is having several grids on hand for making drawings. Constructing a basic grid is one of the fundamentals covered in this chapter. We'll also explore space relationships and other principles of design, and summarize definitions of terms used in this book—starting with the concept of creativity that guides my overall approach to *Watercolor by Design.*

EXPERIMENT, INVENT

"To originate, to build, to design" is one dictionary's definition of creativity. *You* can do that! Dream up a new shape and present it in different ways. Create a texture on something that is usually considered flat and plain. Put the center of interest in the corner of the paper. Change sizes and overlap shapes to make new patterns. Choose realistic subjects as well as abstract and nonobjective patterns. Experiment with unusual color combinations. As you draw, design, and paint, your knowledge of spatial relationships, color schemes, and varied painting techniques will continue to grow. In order to have your own creative style develop, if you get a new idea while you are working, go with that idea! It's all right to make a mistake; you can correct a mistake. In fact, it might not be a mistake. It might represent a breakthrough, an entirely new concept to be explored.

OPPOSITE Marianne Brown, RADIATION, watercolor on paper, 21³/₄ × 15" (57 × 38 cm).
This painting using a radial design is built on the idea of a wagon wheel, with the hub in the middle of a circle. Diagonal shapes formed by the spokes in the wheel radiate from the center. Instead of one circular wheel, the painting is divided into seven circles with radiating shapes in each.

basic design principles

There are many ways to adapt basic design principles to a given painting.

Here are some examples:

- **Variation** of sizes, shapes, colors, and values adds diversity.
- **Repetition** of shapes, colors, and line creates rhythm and balance.
- **Dominance** of a warm or cool color palette helps establish continuity.
- **Contrasting** adjacent values—light-to-dark or warm-to-cool—adds interest.
- **Harmony** results when shapes, colors, and directions are similar.
- **Center of interest** is established with a shape, color, or value contrast that catches the viewer's eye first.
- **Unity** is achieved when colors and shapes are similar and balanced. For instance, instead of scattered birds, draw a group of birds to form a unit.

SPACE RELATIONSHIPS

One way to learn about space relationships is to plan space divisions only (no content within them), using a small notepad or sketchbook. After the first twenty or thirty such sketches, you may think you have exhausted all of your ideas, but don't give up. Try to invent new ways to divide spaces imaginatively. For instance, include more curved shapes. Divide some spaces into smaller ones. Move shapes toward the edges of your paper more often. Consider using fewer shapes. The more inventive you are, the closer you will be to expressing your own personal vision.

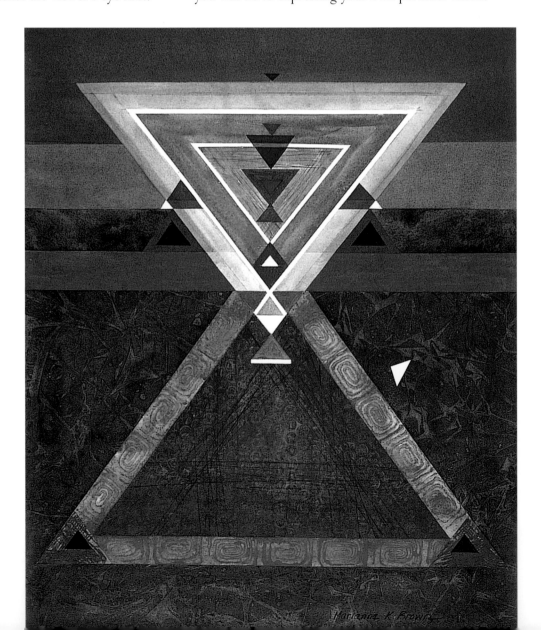

Marianne Brown, INVERSION, watercolor on paper, 21 × 17" (53 × 43 cm).

As you look at this painting, can you find areas where some of the concepts listed under "Basic Design Principles" have been achieved?

Draw many small sketches that show space divisions only.

When arranging spaces for more intricate designs, cut or tear shapes from three or four values of construction paper. Move the shapes around on a selected background. Using white, black, and gray papers to set up the design is helpful because the contrasts are evident immediately. When the design is complete, it can be pasted in place or left as it is to work from later. Since construction paper fades, keep such paper shapes away from light in a folder.

DRAWING A BASIC GRID

SUPPLIES
drawing paper
black Sharpie pen
ruler

A grid is the foundation for many basic design schemes. Once you construct a basic grid, it can be adapted to any size and format that serves your idea: square, rectangular, triangular, circular, and so on.

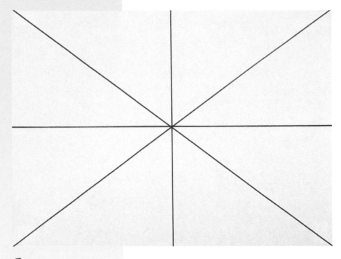

1 Divide the paper from corner to corner. Use the middle of the resulting × as the center, and divide the paper horizontally and vertically.

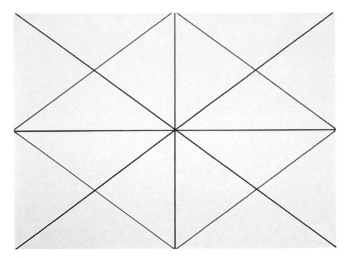

2 Divide the resulting four rectangles (squares) from corner to corner.

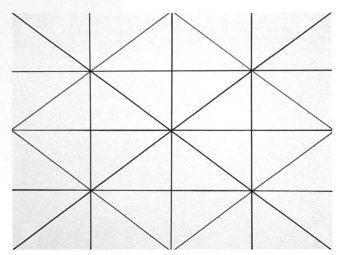

3 Connect the centers of the resulting ×s horizontally and vertically.

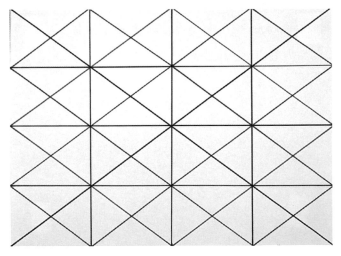

4 Divide the resulting rectangles (squares) from corner to corner. The grid divisions get smaller and smaller as you continue. You may go on in this manner until you have the desired number and size of the divisions needed for your composition. Keep several different grids handy for making drawings.

Tip
KEEP FUNDAMENTAL NOTES

When experimenting with space arrangements, decide on your plan and write yourself a note summarizing your decisions. Putting your thoughts on paper will help solidify your idea and keep you working in the right direction.

terminology

Art terms referred to often in this book are listed here for handy reference. Detailed explanations of color terms will be found in Chapter 4.

Abstract art, the essence of a known subject, is stated in a simplified manner with emphasis on design. The forms may be definite and geometric or fluid and amorphous.

Center of interest, or **focal point,** dominates a painting, leading the viewer's eye to that area first.

Collage combines papers or other materials of various shapes and colors into a composition.

Design is the organization of lines, shapes, colors, values, textures, and direction into an artistic form.

Format refers to the size and proportions of a piece of paper (or canvas) on which artwork is placed, and its orientation (vertical or horizontal).

Monotype is a one-of-a-kind print made by painting with waercolor on a sheet of glass or Plexiglas and transferring the dry image to a sheet of wet paper.

Nonobjective, or **nonfigurative,** art is an arrangement of shapes, line, texture, and colors created without the influence of real or natural forms.

Realistic, or **representational,** art is based on actual figures or objects rendered in a literal, true-to-life form.

Tangent refers to the touching of shapes, creating a point of tension. If touching shapes are repeated, they become part of the design.

Technique is the method of applying watercolor paint, such as on dry paper, wet-in-wet, in glazes, in graded washes, in mixed media, or with varied textures.

Texture, the surface appearance of a painting, is created through certain brushstroke applications, the use of salt or crumpled plastic wrap on wet washes, stamps, and any other tools to create unusual effects.

Values are the tones of colors ranging from light to dark.

Wash is color flowed into an area too large to be covered with single brushstrokes.

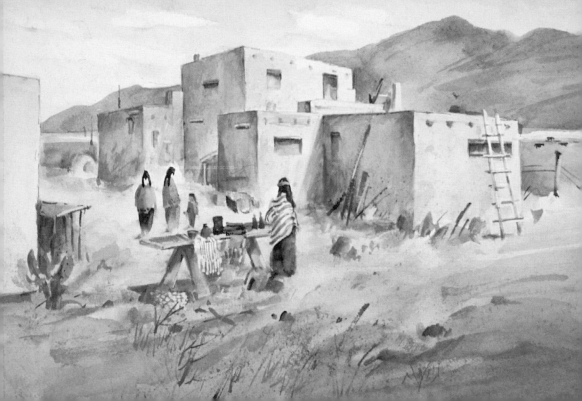

preliminary drawing

Drawing is an important step in planning ideas for your paintings. As you draw you begin to organize subjects by balancing shapes and establishing spatial relationships. Drawings record the journey you make in the pursuit of a special idea, so create a series of drawings before beginning any painting. Then take a long look at them. If they seem somewhat similar, perhaps you are beginning to develop your own personal style and have found a drawing approach to build on that comes most naturally to you. On the other hand, are your drawings all very different? Are your space arrangements varied? Do you put fewer shapes in some drawings and many more in others? Do you move your center of interest each time? If "yes" to all of the above, you are exploring many options for developing your idea. It shows your interest in bringing something new and different to your art. Go for it!

CONSIDER YOUR LIGHT SOURCE

Planning light and dark values in your painting begins with your pencil drawing, with a scale ranging from white to black—lightest to darkest values. Those values depend on how light falls on your subject. Decide if you will work with a **direct, single light source**—daylight coming through a window or from a single lightbulb directed on your subject. A single light source includes backlight, and light coming from the side, front, above, or below the subject. Where light hits objects, values are brightest; on the shadow side, darkest. With **multiple light sources** you position several lamps to produce diffused light. Using an **unplanned light source** means creating values as you work. Light is furnished by the lightest color values in your painting contrasted against medium and darker color values. Color can also be reflected from shape to shape in any type of painting.

OPPOSITE Marianne Brown, TAOS PUEBLO, VISITORS' DAY, (top) graphite on paper, 11 × 15" (28 × 38 cm); (bottom) watercolor on paper, 11 × 15" (28 × 38 cm).
My value drawing (top), made with 2H and 2B pencils, established the source of light on my subject matter, which guided the color values for my watercolor painting (bottom).

transferring drawings

The best way to avoid having to enlarge your work when transferring a drawing to watercolor paper is by using the same standard-size sheets (such as 18 × 24") for both your drawing paper and your watercolor paper. Transfer the drawing by putting it up on a large, sunny window, with your watercolor paper taped on top of it. If you have a light box that's large enough, use that. A resourceful artist I know creates her own light box by working on a glass-topped table with a light placed under it. If your pencil lines are too pale to see clearly through your watercolor paper, go over them with a black Sharpie pen.

CHOOSING PAPERS

The papers you use make a difference. Hot-pressed papers—both for drawing and watercolor painting—have a smooth, even surface; rough or cold-pressed papers have uneven, textured surfaces. Experiment with both. Test pencil lines, shapes, and textures on wet and dry paper. Try pushing and dragging your pencil and drawing with its tip and sides to create combinations of lines. Apply both hard and soft pressure for more variety.

FROM DOODLE TO DRAWING

Keep your doodles. Spread them out and look for similarity of forms and spaces. Could these doodles contain shapes for your paintings? Can you combine parts of some with others to use in your work?

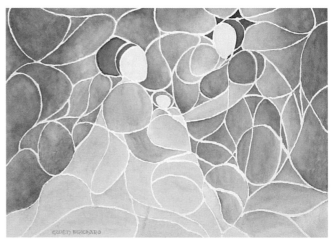

Gwen Prichard, THE PRESENTATION, (top) graphite and ink on drawing paper, 8 × 11" (21 × 28 cm); (bottom) watercolor on paper, 8 × 11" (21 × 28 cm). Gwen's doodle progressed to a value drawing, which she then transformed into this imaginative watercolor painting.

RIGHT **Joyce McConeghey, DOODLE,** ball-point pen on drawing paper, 5 × 3" (13 × 8 cm). By bringing variety to sizes and shapes in her ink drawing, Joyce turns a doodle into an interesting pattern that might become the basis of a colorful painting.

FAR RIGHT **Berna Rasmussen, DOODLE,** Sharpie pen on drawing paper, 10 × 8" (26 × 21 cm). Rhythm, flow, and intricate line work make this doodle a good candidate for development into watercolor art.

COLOR DRAWINGS

If you are eager to get right down to color with your preliminary sketches, instead of working with graphite, use colored pencils, crayons, or pastels. Best of all, if you use watercolor pencils and brushes, you can wet the edges of the lines and create washes on your paper very quickly.

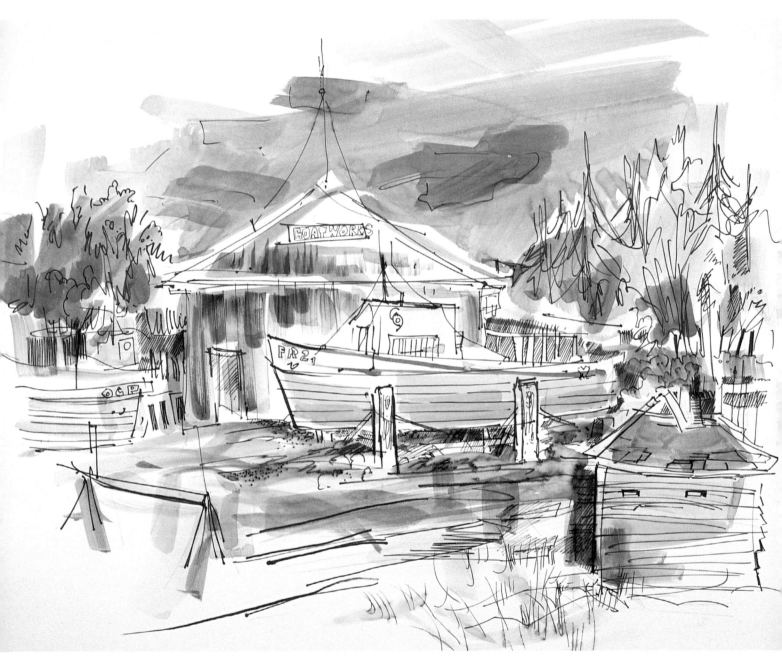

Marianne Brown, BOATWORKS, India ink and watercolor drawing on Bristol board, 10 × 12" (26 × 31 cm).
Especially when sketching outdoors, if you make color drawings for reference, instead of taking photos, it will help you remember the scene more vividly.

USE LINE TO DEFINE YOUR SUBJECT

Creating lines by moving your hand quickly suggests an energetic mood. Moving your hand slowly and deliberately causes a slow line and a more peaceful mood. Experiment by combining fast and slow, thick and thin lines. When you include line work in your watercolors, it will be considered part of your painting technique.

Sally Bellenger, MAX, watercolor and ink drawing on paper, 22 × 15" (56 × 38 cm).
Skillfully drawn thick and thin ink lines combined with gentle watercolor washes give this piece its delightful eye appeal.

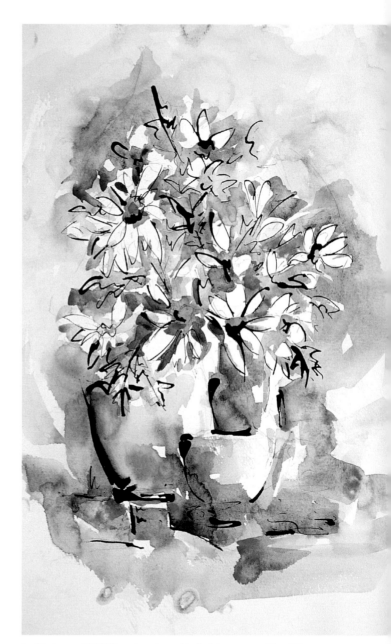

Lucille Jones, DAISIES, watercolor and India ink on paper, 22 × 15" (56 × 38 cm).
Lucille used a bamboo pen to create the delicate ink lines that lend spontaneity and freshness to this watercolor-wash drawing.

SKETCHING TELEVISION IMAGES

A world of people, places, and things for you to sketch is as near as your television set. Obviously, you are going to need to capture the subject very quickly. Subjects sketched this way can be turned into wash drawings later by adding a bit of watercolor.

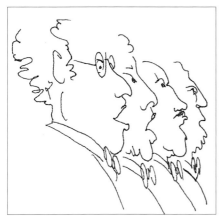 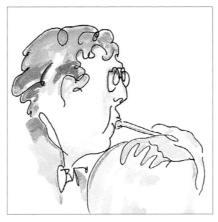 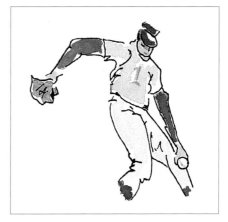

Carolyn Kerr, (left) **FREUDE,** (center) **THE HORN PLAYER,** (right) **READY TO THROW,** Sharpie pen and watercolor on paper, (each) 5 ¹/₂ × 5 ¹/₂" (14 × 14 cm). These three rapidly drawn works were created in front of a television screen. Spare as these lines are, Carolyn's talent for evoking mood and expression with just a few perfect gestures gives her drawings a finished look.

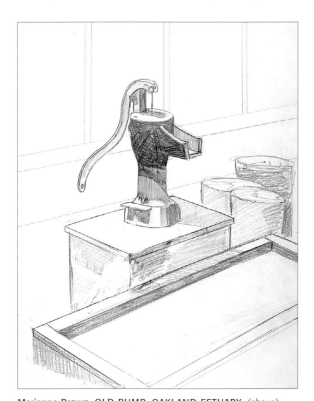

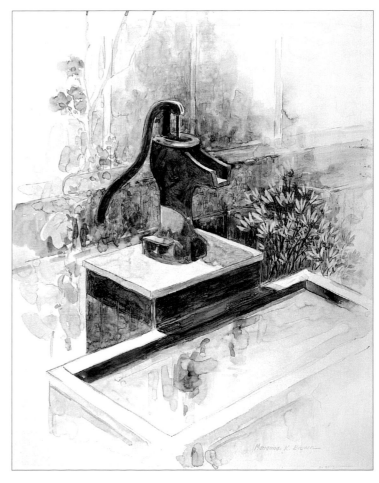

Marianne Brown, OLD PUMP, OAKLAND ESTUARY, (above) graphite on drawing paper, 27 × 21" (69 × 54 cm); (right) watercolor on paper, 27 × 21" (69 × 54 cm).

By drawing first on inexpensive paper, I was able to erase, move details around, and perfect other points before transferring my drawing to fine watercolor paper.

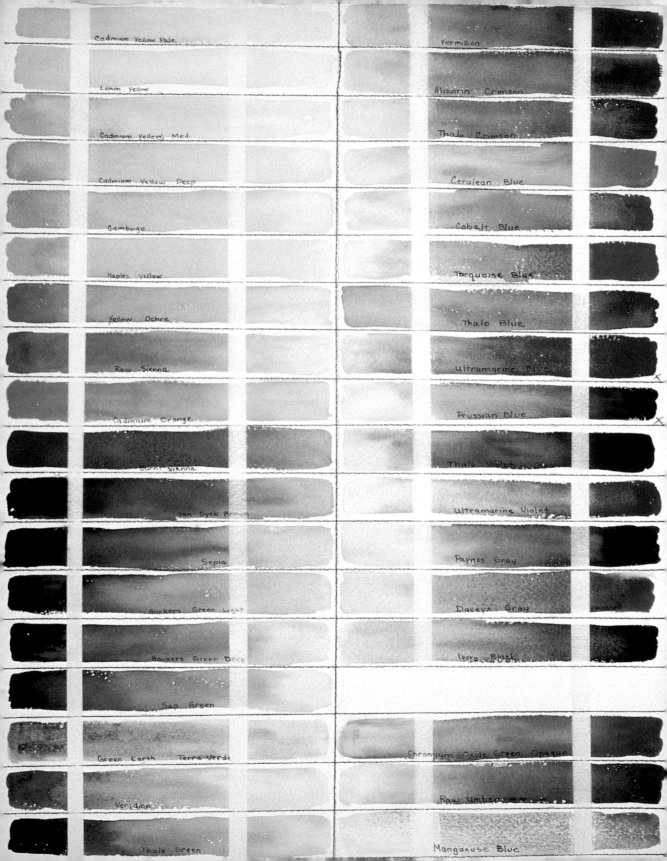

Cadmium Yellow Pale.

Vermilion

Lemon Yellow

Alizarin Crimson

Cadmium Yellow, Med.

Thalo Crimson

Cadmium Yellow Deep

Cerulean Blue

Gamboge

Cobalt Blue

Naples Yellow

Turquoise Blue

Yellow Ochre

Thalo Blue

Raw Sienna

Ultramarine Blue

Cadmium Orange

Prussian Blue

Burnt Sienna

Thalo Violet

Van Dyck Brown

Ultramarine Violet

Sepia

Paynes Gray

Hookers Green Light

Daveys Gray

Hookers Green Deep

Ivory Black

Sap Green

Green Earth Terra Verde

Chromium Oxide Green Opaque

Veridian

Raw Umber

Thalo Green

Manganese Blue

Color reveals the mood, atmosphere, and distance in a painting. Bright, warm colors denote a cheerful or sunny mood. Muted or grayed colors represent a quiet, more peaceful mood. If you want to depict atmosphere and light, use nonstaining colors. To express mass, weight, power, and strength, use opaque or staining colors. Combine pigment groups for contrast. Contrast the weight and density of sedimentary colors with an area of clear, transparent colors. If you use all transparent colors in a painting, it often looks too weak and thin. Glazing—applying layers of transparent color—will add weight, luminosity, and depth to the color.

COLOR LIFTING AND VALUES CHART

The chart on the opposite page shows light-to-dark values of all my paint colors. Use this as a guide for making your own chart for the colors you use. It will serve as a handy reference for lifting off color on artwork after the paint is dry, and when you decide to remove or adjust a color(s) to a lighter value. To lift off each color, protect the surrounding colors with masking tape. Lift the selected color off with a stiff, wet brush, then blot with tissue between the pieces of tape. I have found that I can lift almost any dry color off in this way to some degree, and staining colors can be lifted to a much lighter value.

OPPOSITE Marianne Brown, VALUES CHART, watercolor on paper, 22 × 15" (56 × 36 cm).
This chart is on Arches watercolor paper, the best kind for lifting off color with any taping procedure. (Some other papers are too soft, and masking tape tears the surface.) Lift larger, dried areas of paint with a wet sponge or brush and blot with a tissue to get a lighter value or to get the white paper back.

COLOR SCHEMES

Monochromatic schemes use one color only, in many values. Try burnt umber or sepia for a handsome monochromatic look. **Complementary** colors are directly across from each other on the color wheel (e.g., blue and orange). Variations include a **split complement** (primary plus two colors flanking it) and a **double complement** (two adjoining colors and their complements). **Triads** have a three-color scheme. The three primaries, for instance, offer several reds, blues, and yellows from which to form appealing triads. **Semi-triads** use two colors that have one color in common, plus the complement of one of them (e.g., yellow, yellow-green, red-violet). **Analagous** colors are contiguous on the color wheel, with one primary hue in common (e.g., blue-violet, blue, blue-green, green). Experiment by adding one complement for variety.

Mix colors to get cooler or warmer blacks (e.g., thalo blue, thalo green, and a bit of red for a cool black).

COLOR PROPERTIES

Value refers to the lightness or darkness of a color. Show distance by using colors that are lighter and duller in value; dark-value colors are bolder and often command the center of interest in a painting. **Intensity** is the brightness or dullness of a color. Mix a color with its complement or with black to dull or mute its intensity. **Temperature** indicates how warm or cool a color is. Warm colors are yellow or those nearest to it on the color wheel; cool colors emanate from blue.

Pat Landsberg, WINTER MOON, watercolor on paper, 15 × 11" (38 × 28 cm). Pat's cool, muted, monochromatic palette conveys a pleasing, peaceful mood.

Gordon Towell, STRIPES, watercolor monotype on paper, 22 × 15" (56 × 38 cm). Gordon's colorful painting has a warm, bright and sunny aura.

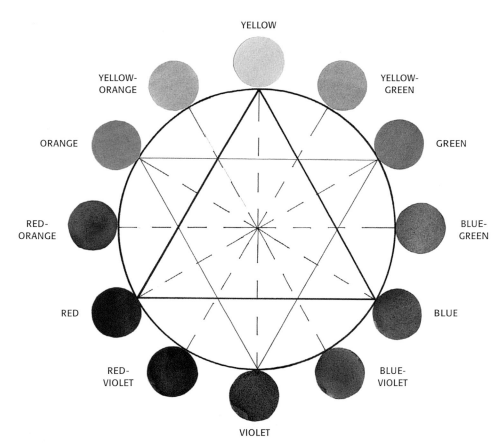

YELLOW

YELLOW-ORANGE

YELLOW-GREEN

ORANGE

GREEN

RED-ORANGE

BLUE-GREEN

RED

BLUE

RED-VIOLET

BLUE-VIOLET

VIOLET

The color wheel is an arrangement of hues showing the rainbow spectrum. **Primary colors** are red, yellow, blue; **secondary colors** are a mixture of two primaries (red + yellow = orange; yellow + blue = green; red + blue = violet); **tertiary colors** are a mixture of a primary and a secondary (red + orange; yellow + orange; yellow + green; blue + green; blue + violet; red + violet).

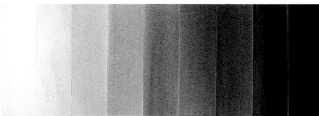

This light-to-dark value scale shows the range of tonality, or value, from a single color: in this case, black. The same light-to-dark value scale exists for every color in your palette. For example, the value scale of the primary red would go from the palest pink through gradations up to the most intense, pure red. Use more water when mixing light values; less water when dark values are needed.

RIGHT A "Palette Preview" similar to this one is part of the demonstration in each chapter ahead. This sheet is designed to help you experiment with combinations and values of colors for your painting. As here, begin by painting and labeling a square of each color you choose at the top of a 22-x-15" sheet of watercolor paper. (In this case, I've used a double-complement palette.) To test colors accurately, use the same kind of paper you will use for your painting. Grade each color from its darkest to its lightest value. Wet the rest of the paper and apply clear values of the colors first. Add the other colors and overlap them to see the result of various mixtures. Try to get a range of values; mix darker values as the paper dries. You can add darks on dry paper later, but the colors will not flow into each other as well.

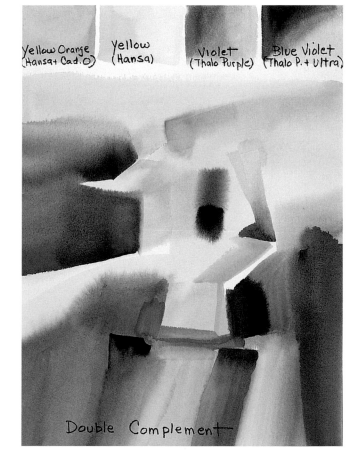

Yellow Orange (Hansa + Cad. O) Yellow (Hansa) Violet (Thalo Purple) Blue Violet (Thalo P. + Ultra)

Double Complement

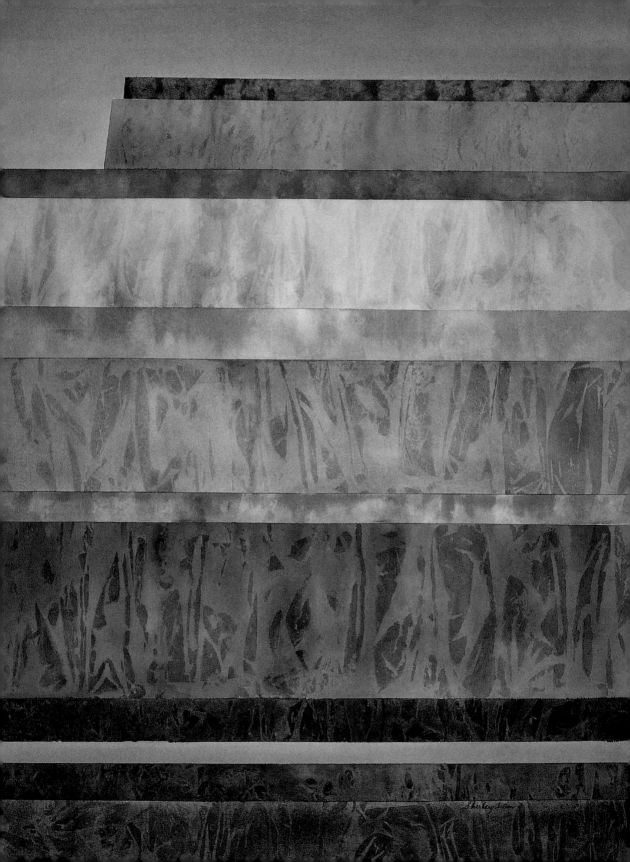

horizontal DESIGN

In a painting using horizontal movement as the basic design layout, shapes and lines that move across the paper dominate the composition. Other subordinate shapes that are not horizontally oriented may be added to suit your idea and subject matter.

Horizontal rhythms in a painting impart a feeling of calm and restfulness. Landscapes and seascapes most often exhibit a horizontal design motif, but you may also paint reclining figures, still-life objects, and abstract or nonobjective shapes arranged horizontally. When single brushstrokes and broad strokes used as washes are painted horizontally, they help reinforce the main flow of the design.

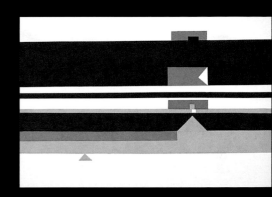

BASIC HORIZONTAL-BAR DESIGN
Construction-paper collage, 8 × 12" (21 × 31 cm).

Consider the above principles of horizontal composition as you decide what your subject will be. Make rough pencil sketches of your idea or build collages with bits of construction paper as a first step. Determine how far apart to place the shapes in your design. Do you want any of those shapes to be intersected by other shapes? Does your idea have a center of interest? What is the mood you want your painting to convey, and will you express it through realistic subject matter or abstractly? Your colors can contribute to mood: blues and violets are a good choice to create a peaceful aura; reds and yellows for a more lively feeling. Along with color, think of value, line, and texture as you plan your painting. Then use the demonstration on the following pages as a guide to building your own horizontal design.

OPPOSITE Shirley Acton, AFTERNOON AT THE GRAND, watercolor on paper, 30 × 22" (76 × 56 cm).
This palette of burnt sienna, Indian red, cobalt blue, ultramarine blue, and yellow ochre conveys a warm feeling for the rugged rock walls at the Grand Canyon. Shirley dabbed crumpled plastic wrap on wet paint to suggest the texture of rocks in her fine, abstract view of the scene.

CALIFORNIA AQUEDUCT

SUPPLIES

11 × 15" sketch paper

22 × 15" cold-pressed
watercolor paper

11 × 15" cold-pressed
watercolor paper

2" flat watercolor brush

1" flat watercolor brush

pencil

masking tape

light box

three tube watercolor paints

watercolor pencil

hair dryer

It is a hot, sunny day. I am driving in my car. The California Aqueduct built along the roadside looks cool and inviting. When I get back to my studio, I am still thinking of that wonderful scene, and decide it would be a great idea for a horizontal-bar painting.

1 DRAW STRUCTURE. I begin by making several sketches, using the same size paper as I've chosen for my watercolor painting. This will enable me to transfer the drawing without resizing it. These three drawings were my final choices, and among them, the first (above left) is the one I settled on for my design layout.

2 PALETTE PREVIEW. I've decided on a split-complementary color scheme. The violet (top left) is a mixture of cobalt blue and red rose deep. The yellow-orange (top center) is a mixture of cadmium red light and gamboge hue. The yellow-green (top right) is a mixture of gamboge hue and cobalt blue. Since paint reacts differently on different kinds of paper, I use the same kind of paper for this sheet as I'll use for my painting, but it is larger (22 × 15"), providing more room for experimentation. Testing various values and mixtures of my colors helps me to determine the range I'll use in my painting.

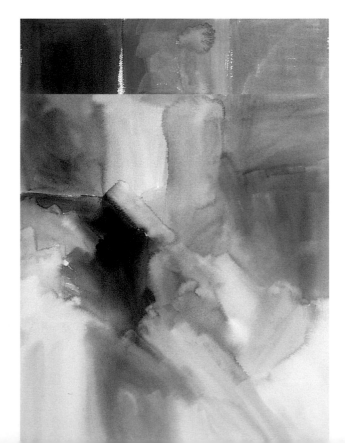

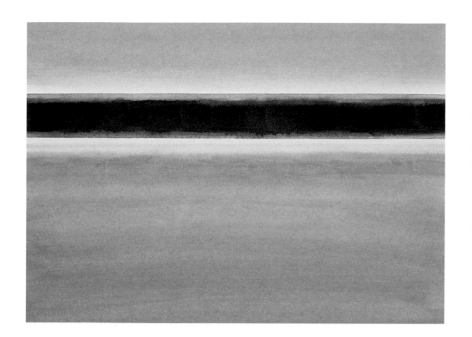

3 TRANSFER DRAWING. I placed my sketch on a light box with my watercolor paper on top of it and traced the design with pencil. Then I put the watercolor paper on a clean, flat surface. Using a 2" flat brush, I put clear water on the top and bottom areas only, and avoided wetting the main horizontal-bar area. Painting on the wet areas only, I put down the first values of yellow and yellow-orange, then added the yellow-green strip and let the paper dry. After wetting the main horizontal bar, I painted the dark violet shape with a 1" flat brush, and let the paper dry.

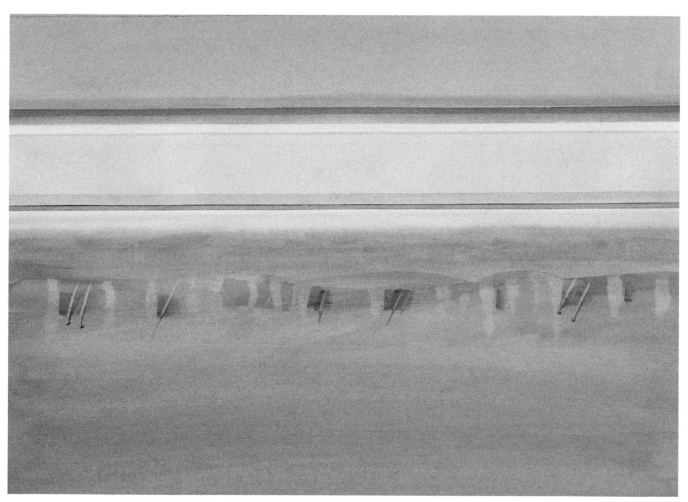

4 MASKING. I applied masking tape to block out the main horizontal bar while working on other areas. For texture, I added orange brushstrokes to represent the grasses along the roadside. To balance the green color of the grasses, I added a thin line of yellow-green above the taped area and let it dry. Before going to the final step, I will remove the masking tape by warming it with a hair dryer on a low setting and then pulling it off gently at a slight slant.

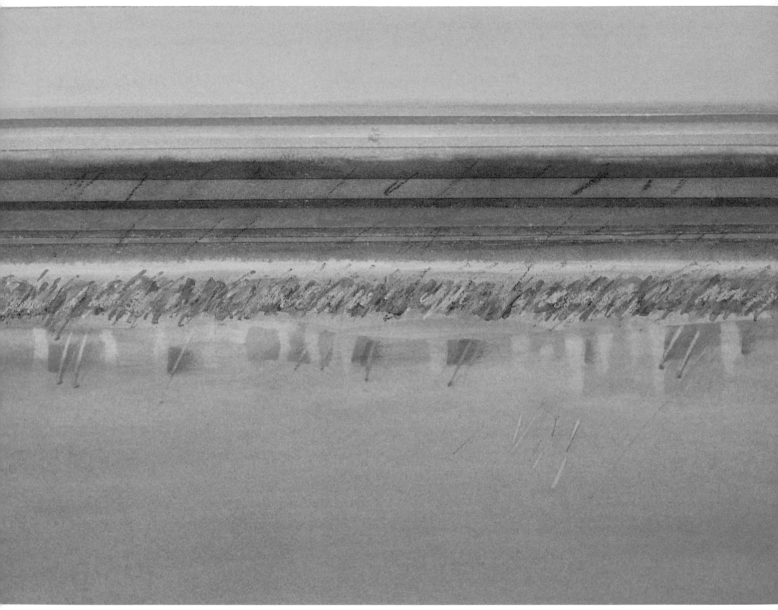

Marianne Brown, **CALIFORNIA AQUEDUCT,** watercolor on 140-lb cold-pressed paper, 11 × 15" (28 × 36 cm).

5 FINAL TOUCHES. The cool water in the aqueduct was moving along slowly when I visited the scene, so I chose to alter some values in the dark violet shape to suggest changes in the water's surface. Using a watercolor pencil, I added a few light diagonal marks to depict the flow of the water. Finally, I accented the texture in the green strip depicting the grass along the aqueduct. In using my imagination to transform the scene I enjoyed from my car into a strong horizontal design, I chose warm colors to portray the sunny day and contrasting cool colors to suggest the aqueduct's water and its lively reflections.

Tip
COLOR MOOD

Just as I did for *California Aqueduct,* select the colors for your painting to suit the mood of your subject. Here are some color groups to consider: bright colors, muted colors, many colors, few colors, dominant cool or warm colors, or several values of a single color.

other ideas to consider

In addition to the step-by-step instructions on the previous pages, the following tips will be useful in creating your own horizontal watercolors. These ideas may also be applied to the other eleven design motifs that fill this book. For added ideas and inspiration, study the gallery of other artists' works on the pages immediately ahead.

THINK OUTSIDE THE BOX

Look at your sketches. Can you delete some parts to make them simpler? Is your sketch getting too horizontal? Does the plan need some other shapes for variation? Divide your paper into two or more sections and vary the horizontals in each part. Repeat a color in different sections on your paper to form an implied horizontal in your painting. Select a painting from another design in the book and convert it to a horizontal theme. Think of a subject that is never presented horizontally and adapt it.

APPLYING PAINT WITH A RULING PEN

Ruling pens are designed to make straight lines with ink, but you may also fill the pen with watercolor paint. When doing so, be sure that the nibs are close enough to prevent the paint from running out; there's a small screw on the side of the pen for adjusting the nibs. Then fill the pen by wiping a paint-filled brush between the nibs. Practice on a spare piece of watercolor paper to perfect this technique. Clean and dry the pen when finished.

APPLYING MASKING FLUID WITH A RULING PEN

When you plan white lines in your painting and want the white of the paper to become those lines, use masking fluid, which will block out white paper more easily than masking tape for thin lines. Here again, the versatile ruling pen comes in handy. To use masking fluid with a ruling pen, load the fluid with a brush, but first, protect the bristles by rubbing a slightly wet brush on a cake of mild soap. Next, dip the brush into the masking fluid and wipe it between the pen nibs. Practice this procedure on scrap paper. If the fluid leaks out, tighten the space between the nibs. After the fluid dries, complete your painting. Then remove the hardened fluid from your dry watercolor paper with your finger or the sticky side of a piece of masking tape.

horizontal designs

Tom White, RENAISSANCE FACADE, watercolor on paper, 14 × 20" (36 × 51 cm).

Tom drew an architectural elevation of these buildings, then added a floor plan and inverted it along the base of the structures. He chose a subtle palette to depict the ancient flavor of the buildings, and blocked out several areas with masking fluid to save the whites. The contrast of white structures and a darker floor plan forms a horizontal base separating the two sections. For textures, he sprinkled salt on wet washes, and added ink lines to accent details.

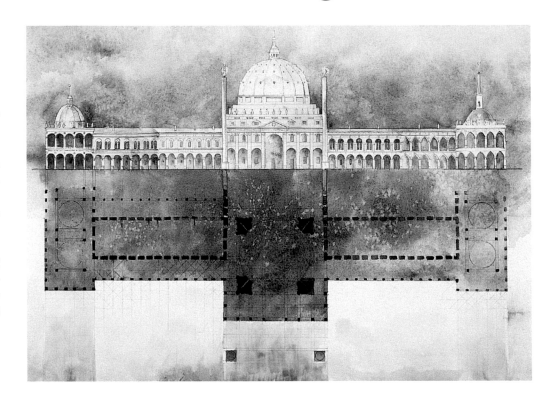

Susan Dennis, TAHOE SNOW, watercolor and collage on paper, 11 × 15" (28 × 38 cm).

This horizontal motif is reinforced by bands of texture and color. Susan cut out the mountain shapes on watercolor paper and glued them to her base watercolor sheet. After spraying the mountain area with water, she drew India ink lines on them while the paper was still wet. Her palette is a mixture of cobalt and ultramarine blues with a touch of yellow ochre for painted sections of the sky and water.

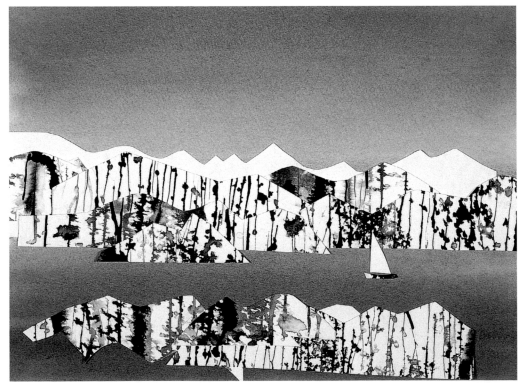

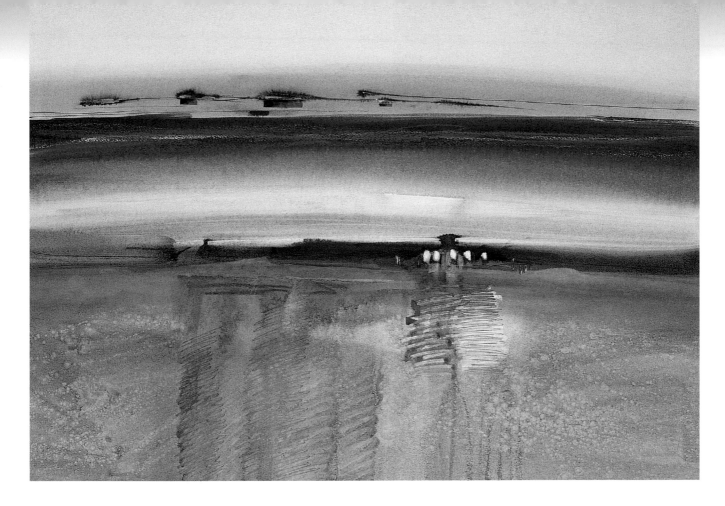

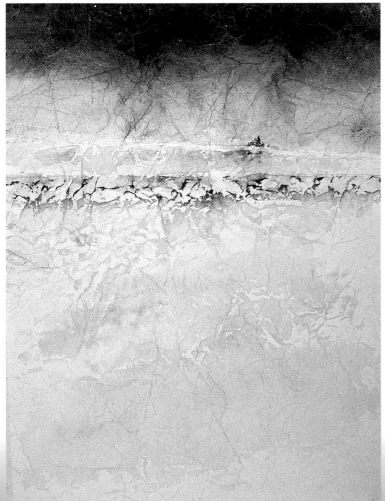

ABOVE **Marianne Brown, WATERFRONT,** watercolor on paper, 22 × 30" (56 × 76 cm).

My personal view of a seascape at Jenner, California, is based on a complementary color scheme of ultramarine blue, cadmium orange, and cadmium red light, with bits of cadmium yellow medium and cerulean added for variation. While my paper was wet, I scratched into some color with a brush handle. Then I used little brushstrokes to suggest distant waves and blue vertical marks to suggest a reflection of water on the beach. When the paper was dry, I added pencil marks to repeat the scratched-out texture.

LEFT **Ruth Baldwin, WINTER SUNSET,** watercolor on rice paper, 22 × 15" (56 × 38 cm).

Whereas the other examples in this Gallery were all painted on sheets of paper that have horizontal formats, here is a successful example of a horizontal design adapted to a sheet of paper with a vertical format. Ruth's cool palette evokes a chilly winter scene. Instead of relying on colors usually chosen to say "sunset," such as yellows and oranges, she offers a monochromatic palette that perfectly expresses a snowy day at dusk. The texture was achieved by painting on dry, crinkled rice paper glued to watercolor paper.

Marianne Brown, GREEN FIRE, SEDONA, ARIZONA, watercolor on paper, 11 × 15" (28 × 38 cm). I used the same sketch and "Palette Preview" for this painting as I did for *California Aquaduct* (pages 32–34). A series of colored strips suggests the tops of distant rock forms. The grasslands in the foreground contain a few diagonal brushstrokes, adding variety to the large green wash. The floating yellow-green bar represents "green fire"—the flash of light seen at sunset. Note that all the basic horizontal shapes have hard edges; soft edges are found inside those shapes.

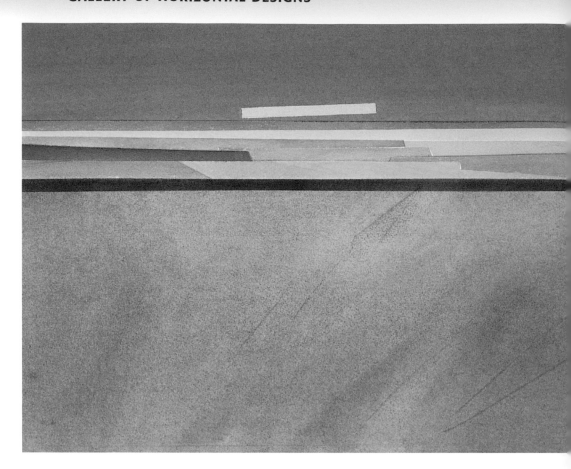

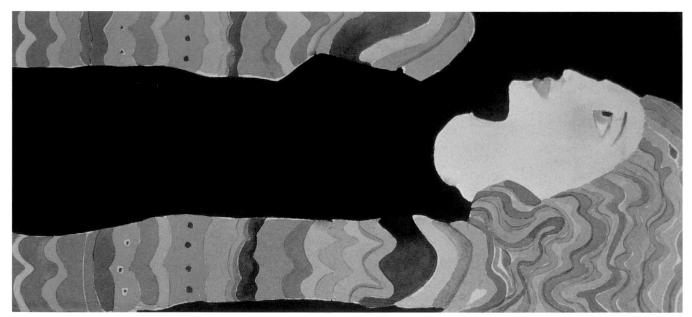

Bea Jae O'Brien, WOMAN, watercolor on paper, 7 × 14" (18 × 36 cm).
Although figures are most often depicted upright in a vertically oriented composition, by reclining her *Woman,* Bea Jae created this imaginative horizontal design. She experimented with combinations of analogous colors and their complementary counterparts, and used black to achieve good contrast in the values of her painting. Wonderful rhythms in the hair and background enhance her idea.

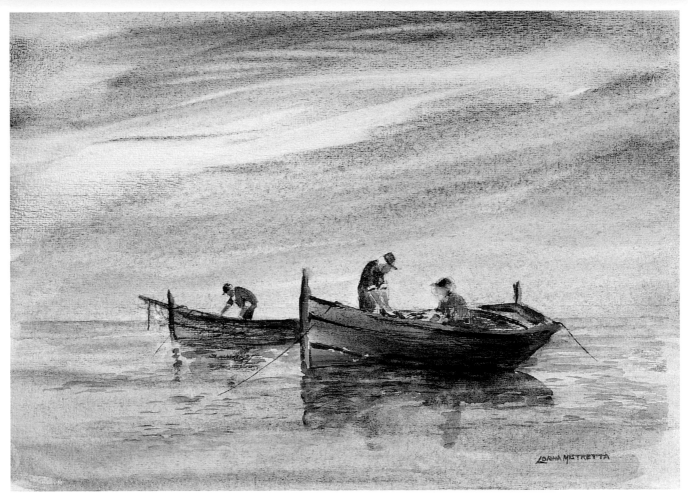

Lorna M. Mullick, **FISHING BOATS**, watercolor on paper, 11 × 15" (28 × 38 cm).

This painting of a misty evening shows fishermen just finishing up for the day. Lorna chose ultramarine blue, cobalt blue, and burnt sienna as her warm palette, using a wet-in-wet technique and different combinations of those colors to portray the sky and water. Her basic design presents the strong horizontals traditionally found in seascape paintings.

Arno Schniewind, **HORIZONTAL BAR,** watercolor on paper, 15 × 22" (38 × 56 cm).

With a humorous, double-entendre title, this horizontal bar of a bar features light colors to give the impression of muted light on the objects and setting. Working wet-in-wet, Arno used close values of ultramarine blue, burnt sienna, yellow ochre, and cadmium red, and painted the scene in a loose, representational style.

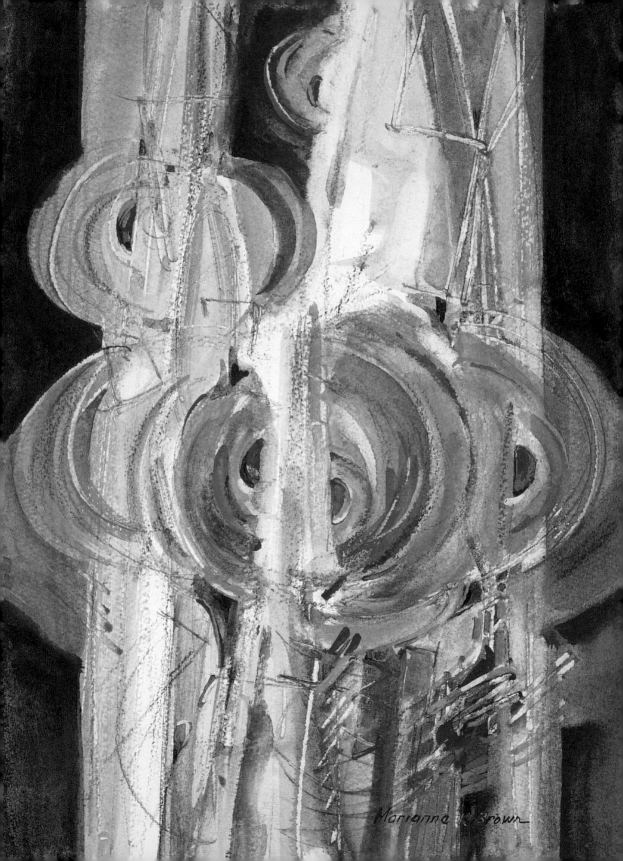

Marianna R Brown

6

vertical
DESIGN

Look through your reference photos and sketches with an eye toward choosing a favorite subject that has repeated vertical patterns. For example, because of their upward thrust, figures, buildings, and trees lend themselves most naturally to vertical rhythms.

In planning your painting, always consider the size, value, and spacing of the objects. The vertical forms should be dominant, so leave out shapes that destroy or interfere with your intended

BASIC VERTICAL-BAR DESIGN
Construction-paper collage, 8 × 12" (21 × 31 cm).

design. However, other shapes can be introduced for variety, but the vertical forms should be most obvious. You can strengthen those forms by painting your initial washes with vertical brushstrokes.

When painting a still life, choose tall bottles, stacked boxes, and jars holding long-stemmed floral arrangements. Look around your house for other objects that have a vertical orientation. Outdoors, you might arrange a still life featuring a grouping of rakes and shovels against a picket fence. Whether your painting approach is realistic, abstract, or nonobjective, think about the feeling you wish to express. How will color, value, and texture enhance your idea? Create a certain mood by using fast or slow brushstrokes. Careful, slowly applied strokes convey a peaceful mood; rapid strokes denote action, emotion, excitement.

OPPOSITE Marianne Brown, AERIAL VIEW, IRRIGATION PATTERNS, watercolor on paper, 15 × 11" (38 × 28 cm).
This painting is based on my impression of a landscape scene viewed from thousands of feet in the air. I had made sketches on a plane trip as I looked down at intriguing irrigation patterns on the fields below. My choice of warm colors is meant to convey the idea of the hot weather during a peak irrigation season.

FISHING

While on a trip in Oregon, I photographed fishermen at Clear River. The men were all intent on their sport, yet a relaxed atmosphere prevailed. A slight breeze ruffled the water; the air was warm, and it was a good place to stop for lunch. I decided that these fishermen were ideally suited to a painting with a strong vertical design.

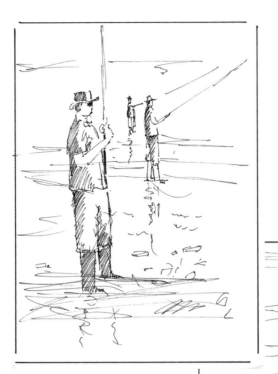

1 DRAW STRUCTURE. I sketched my idea in many different ways, turning my paper to try both vertical and horizontal formats. Of my final three choices of drawings, I thought the first (left) best displays a good center of interest, the postures of the men, and the verticality I wished to emphasize in this painting. I've saved the other sketches, which could lead at some point to a series of paintings on the same subject.

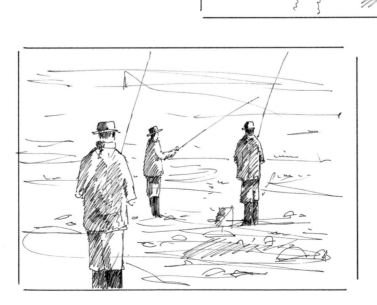

2 PALETTE PREVIEW. Here are various blends and values that result when mixing burnt sienna (top left), ultramarine blue (center), and raw sienna (right). The paper is the same kind used for my painting, although this sheet is larger (22 × 15") to provide more room for experimentation. Testing various values of colors in this way helps determine the range to use in my painting, so I keep this trial sheet nearby and check it frequently for color possibilities as I paint. Bright colors to be used for clothing were added.

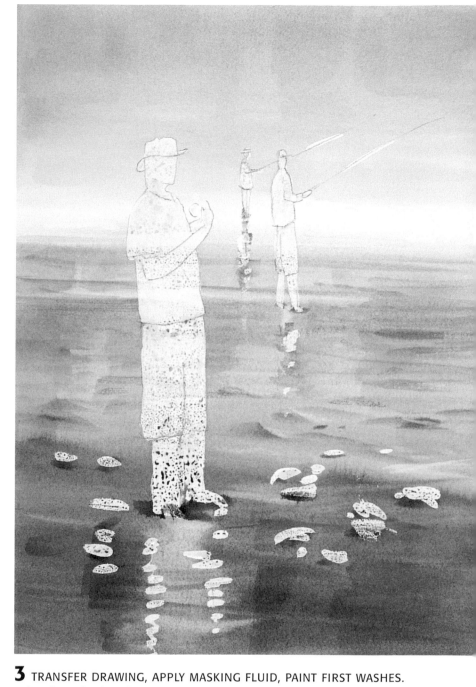

Tip
USING MASKING FLUID

I chose Colorless Art Masking Fluid by Winsor & Newton and applied it with a no. 10 round brush. But first, I wet the brush and wiped it on a bar of mild soap to keep the fluid from damaging the bristles.

3 TRANSFER DRAWING, APPLY MASKING FLUID, PAINT FIRST WASHES. I placed my sketch under my watercolor paper, and with masking tape, tacked them up against a window that was admitting bright sunlight. After tracing the basic forms with a pencil, I moved the paper to my drawing table and brushed masking fluid (see "Tip" left) on the shapes of the figures to block them out in preparation for painting the first wash. When the masking fluid was dry, I placed the paper flat on a bath towel. With my 1" flat brush, I wet the paper evenly; the towel absorbed any excess water along the paper's edges and prevented back-runs. With the same brush dipped in ultramarine blue, I graded the first wash from light at the top to a darker value at the bottom of the sheet. While that wash was still wet, I graded raw sienna darker at the bottom to lighter at the top to depict the muddy water at the shore of the river and to balance that hue in the whole painting. Then I added a few wet-in-wet brushstrokes to show uneven light on the water, and let those washes dry.

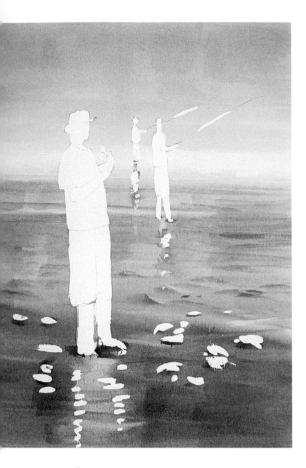

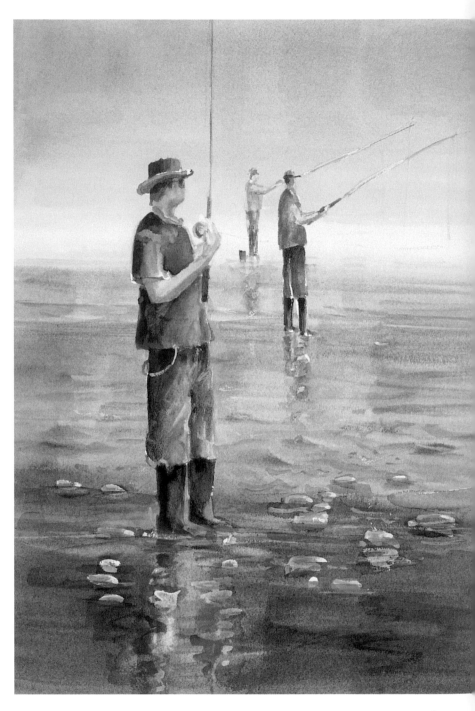

4 REMOVING MASKING FLUID. Although masking fluid must be dry before applying washes near it, I'm careful not to leave it on my paper too long or it may get too hard and will never come off. To remove it, I used the sticky side of a piece of masking tape and pulled it up gently.

Tip

ABOUT REFLECTIONS

Remember, reflections in a painting are directed toward the viewer, and shadows are directed by the sun or an indoor light source. Shadows in this painting are agitated by the movement of the water and are not visible.

Marianne Brown, FISHING, watercolor on 140-lb cold-pressed paper, 15 × 11" (38 × 28 cm).

5 FINAL TOUCHES. The figures and shapes in the water have more rounded edges than straight ones, so I chose round brushes nos. 10 and 12 for completing my painting. I painted the clothing and figures with graded washes to keep my technique consistent. Finally, I enhanced some detail on the figures and foreground.

other ideas to consider

If you add a secondary shape to your vertical design, repeat that shape in different sizes or colors to create balance. Such shapes add interest, but should remain secondary to your main design theme. For example, visualize a tall building with diagonally shaped awnings jutting out over ground-floor windows. Find ways to repeat those diagonal shapes here and there—perhaps in the form of signs or shadows elsewhere in the painting.

THINK OUTSIDE THE BOX

Think about how to use vertical motifs in different ways. You might choose one of the basic grids and add vertical shapes in each part so that the vertical rhythms dominate. Paint vertical reflections in quiet water. Plan an interior scene with vertically striped furniture, wallpaper, and rugs—and a striped cat? Focus only on table legs and chair legs with an interesting background. How about painting vertical plates in a dish rack, sailboat masts as lined up in a marina, or a parade of figures?

TURN YOUR PAPER

When painting a vertical design, don't be confined to a vertical format—that is, the direction in which your paper is oriented. Turn your paper and make some trial sketches that way. If the structure of your design is based on strong vertical rhythms, they will prevail, even though the direction of your paper is horizontal.

PAPER SUPPORT

Some watercolorists place their paper on a board or piece of Plexiglas, especially when they work standing at an easel. But if you prefer to paint seated, with your watercolor paper lying flat on a table, place a clean bath towel under your painting. It will absorb excess water and paint and prevent run-backs.

GALLERY OF
vertical designs

RIGHT **Laura Hill, ABSTRACT,** collage on mat board, 11 × 11½"
(28 × 29 cm).

Laura cut many different shapes from an ecru-colored wallpaper and backed her interesting geometric cutouts with dark mat board. The direction of most of the shapes displays a consistent vertical rhythm. Just as in working with watercolors, when planning a collage that does not include paint, pleasing colors and varied shapes like these can come together in a way that is very appealing to the eye.

BELOW **Carol Jurasin, WILD THINGS,** watercolor on paper, 15 × 22"
(38 × 56 cm).

The viewer doesn't always need to know the intent of the artist, but the title of this lively piece of art tells the story. Carol's idea was to attenuate, or thin out and decrease, forms and colors by floating some, overlapping others, and altering values in a dominant vertical pattern that combines both straight and curved lines. Her idea grew out of a classroom exercise in which I asked students to work on attenuating colors and forms, which Carol certainly accomplished in a commendable way.

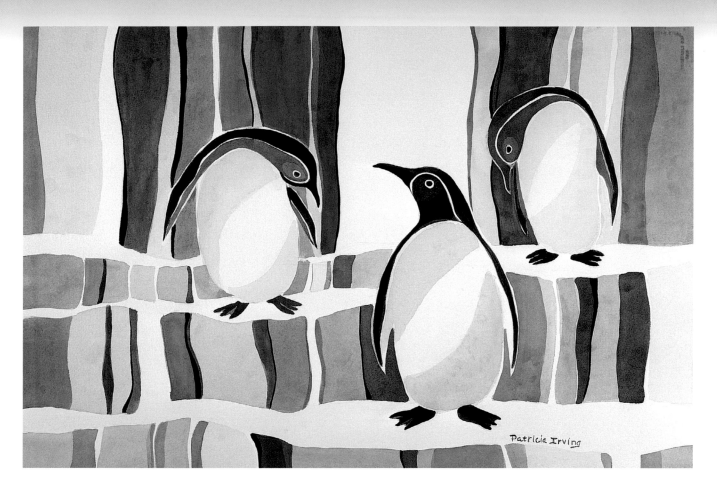

ABOVE **Patricia Irving, PENGUINS ON ICE,** watercolor on paper, 15 × 22" (38 × 56 cm).

On a background of light values with colors reflected from the sky and sunset, Patricia painted contrasting round shapes of the penguins in a way that reinforces the vertical rhythms of the composition. She applied Chinese white watercolor paint over several areas to suggest chill and frost. With attitudes and personalities expressed in each pose, the result is a skilled and refreshing work of art.

LEFT **Masaye Nakamura, FORECAST: RAIN TODAY, CLEARING TOMORROW,** watercolor and collage on paper, 22 × 15" (56 × 38 cm).

To portray a gray, dreary day, instead of using gray paint right from the tube, Masaye mixed all the grays from sepia, burnt sienna, thalo blue, ultramarine blue, permanent rose, cadmium red, and yellow ochre—a fine example of how successfully grays can be created from a range of colors. After applying a mingled wash, the artist added tissue strips, threads, and pieces of other paintings, plus some warm color near the center to express a bit of hope for the "clearing tomorrow" of the title.

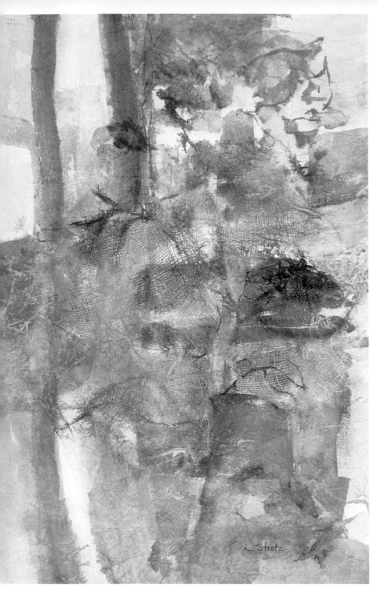

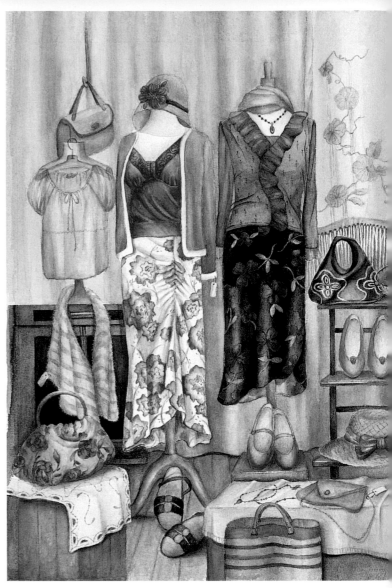

Lorna Strotz, FLEUR, watercolor and collage on paper, 22 × 15" (56 × 38 cm).

Initially, Lorna wanted to experiment with watercolor paints and textures. She applied her paint on wet paper with her subject of flowers in mind, but her aim was to keep the subject abstract and vertical. Some brushstrokes suggest stems, and others suggest leaves and floral forms. When the painting was dry, she used clear glue to paste a single piece of gauze over the central area, bringing a soft, dulling texture to the colors and pleasing contrasts to the values.

Gayle Taylor, SECONDHAND ROSE, watercolor on paper, 18 × 14" (46 × 36 cm).

Gayle was drawn to the lively window display of a secondhand store. She photographed it for reference, then replicated the scene directly on watercolor paper. The unusual arrangement of disparate items, changing sizes, and varied textures contributes to the strength of this vertical composition.

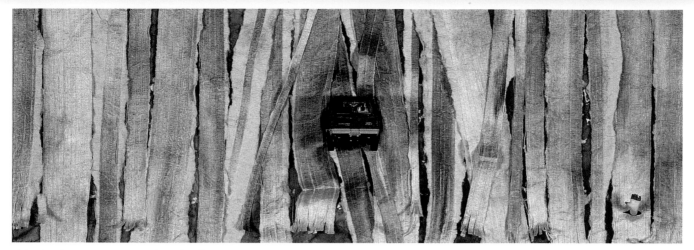

Rich Bringel, CAR WASH, watercolor with collage on paper, 6 × 24" (16 × 61 cm).

To quote Rich, "I want to invite the viewer to question whether they should hesitate the next time they see their car disappear into a pile of wavy rags at the car wash." Notice the raised hand at the bottom right corner. Does it point to danger? The disappearing vehicle is the back half of a toy truck; the disappearing hand is also part of a toy. The rhythms are basically vertical. On a ground of red underpainting, Rich added textured papers that he cut, fringed, and painted to represent the wavy rags. This is a good example of how good planning can turn an unusual idea into a successful painting.

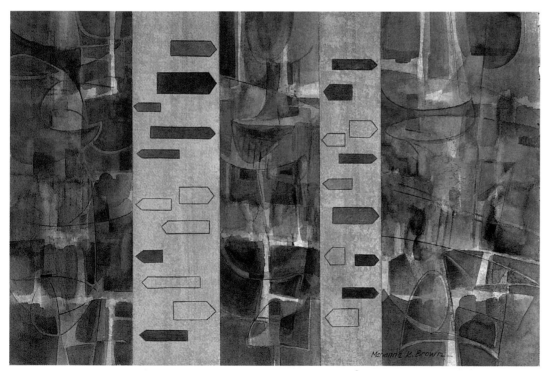

Marianne Brown, COUNTERPOISE, watercolor on paper, 15 × 22" (38 × 56 cm).

A balance of flat washes and mingled washes marks this painting. I used masking tape to divide the vertical spaces, and chose a warm color scheme of raw sienna, raw umber, yellow ochre, cadmium red, cadmium orange, and alizarin crimson. To create varied textures, I applied pure color for the flat washes and mixed colors for mingled washes. The arrows were added as a last-minute accent, which I thought would be an amusing touch to lead the viewer's eye and lend movement to this nonobjective composition.

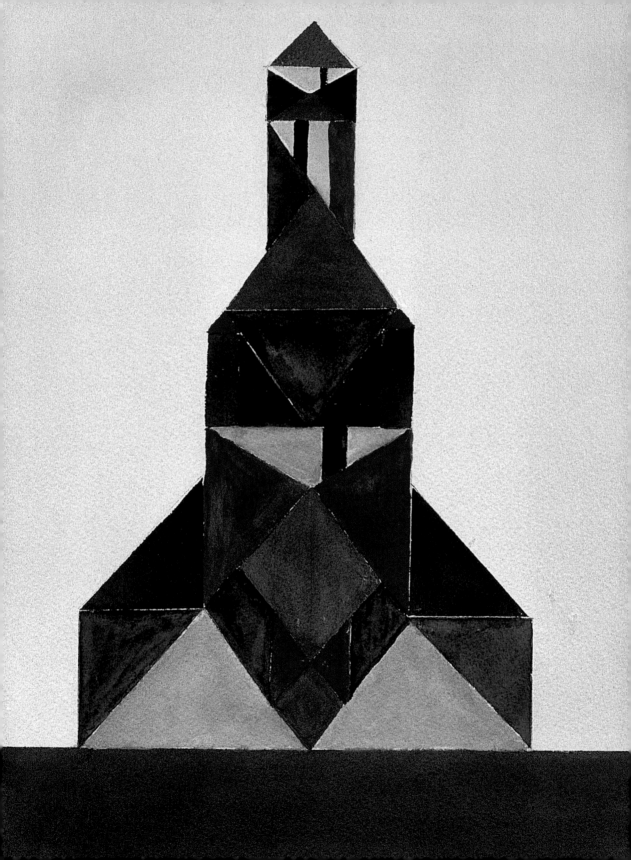

7

pyramidal

DESIGN

A pyramid always has a strong horizontal base with sloping sides that rise upward and meet at an apex. When creating a watercolor painting using a pyramid as its structure, the arrangement of your subject matter forms a triangle on your paper. You may include some shapes that digress from the pyramid, but a triangular structure that contains most of the shapes will unify your design. The horizontal base can be a shape, color, selection of close values, or it may have a definite texture.

BASIC PYRAMIDAL DESIGN
Construction-paper collage, 8 × 12" (21 × 31 cm).

The triangle that forms your design may have equal or unequal sides. When you've decided which it will be, be consistent with that pattern. Have the directions of arms, legs, masts, branches, flowers, still-life objects, or geometric shapes follow the outline of the pyramid that you've worked out.

In terms of subjects, the pyramidal composition is a classic one for placing a group of people in a painting. The apex is often the head of a central figure, flanked by two or three other people at lower levels to fill the triangle. Another subject to consider is a bouquet of flowers arranged with the pyramid in mind. If you wish to paint buildings, place foliage, clouds, or foreground details in positions that fit the triangular motif. Of course, abstract or nonobjective paintings offer infinite ways to arrange shapes, lines, textures, and colors within a triangular structure.

OPPOSITE Rose Posey, TANGENTS, watercolor on paper, 15 × 11" (38 × 28 cm).
This colorful arrangement of geometric shapes shows the strong horizontal base of a pyramidal design. A succession of additional shapes completes the structure's triangular form. Before applying her paint, Rose put masking tape around each shape to define the hard edges that touch one another and become the tangents.

ESCAPADE

SUPPLIES

15 × 11" sketch paper

22 × 15" hot-pressed watercolor paper

15 × 11" hot-pressed watercolor paper

basic grid

pencil

light box

round brushes nos. 6 and 12

three tube watercolor paints

I don't have an immediate idea. So I start sketching by making simple small, medium, and large geometric shapes, using the pyramid as the dominant structure.

1 **DRAW STRUCTURE.** In making a series of sketches using the triangular arrangement, I worked with my basic grid (see page 18). By placing drawing paper over the grid, it was easy to draw the sharp diagonal, horizontal, and vertical lines for my composition. The first sketch shown (above left) is my choice, because it reminds me of a stylized, motionless kite.

2 **PALETTE PREVIEW.** I decide on a scheme of primary colors based on gamboge hue, alizarin crimson, and thalo blue. This trial sheet (on 22 × 15" watercolor paper) should help me determine color values for my painting—but it doesn't, because I've made too many color blends for my simple kite. I am guided instead by the light-to-dark values of my three unblended hues, shown at the top of the sheet.

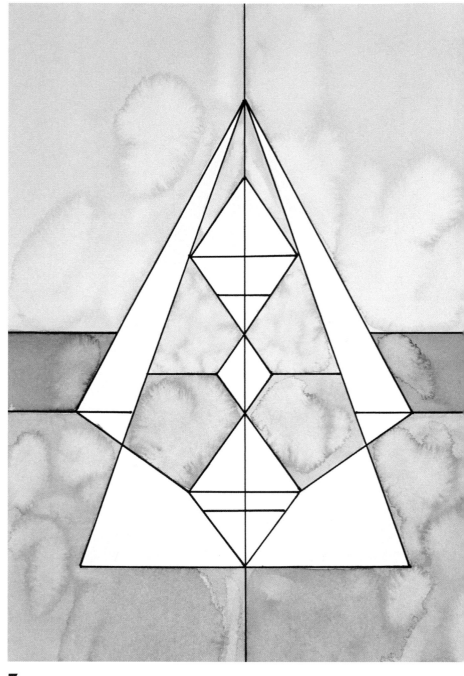

3 **TRANSFER DRAWING, APPLY FIRST WASHES.** Using a light box, I transferred the sketch with pencil to my 15-×-11" watercolor paper.

With a no. 12 round brush, I applied background washes in different values of thalo blue. I used the no. 6 round brush within the smaller shapes. While the washes were still wet, I dropped clear water on selected areas so the color would separate and diffuse, creating the "balloon" effect. Arches 140-lb hot-pressed watercolor paper is the best paper to use when you want to make the paint move with drops of clear water.

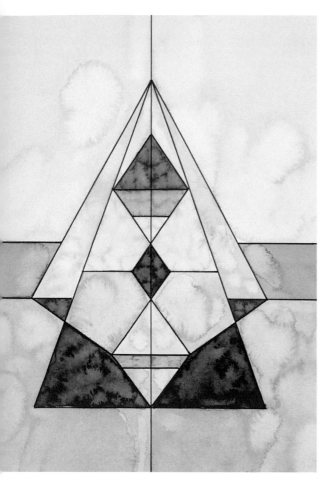

4 APPLY OTHER COLORS. With a cloudy blue "sky" in place around my kite, I added the other colors, being careful to balance the three colors, values, and textures. It was time to put the painting in a mat and have a long look at it. (Sometimes when I study a painting, it takes several days before I decide where it needs a finishing touch.)

Tip
SCORED LINES

If you want to add some darker accents to a painting that has sharply ruled lines, such as *Escapade* (above), score some of them. A scored line produces a nice variation to other lines in a painting, because paint that seeps into the score adds a dark line of color. To score paper, use a butter knife or other blunt-ended tool, or a compass point that isn't too sharp, so it doesn't cut your paper.

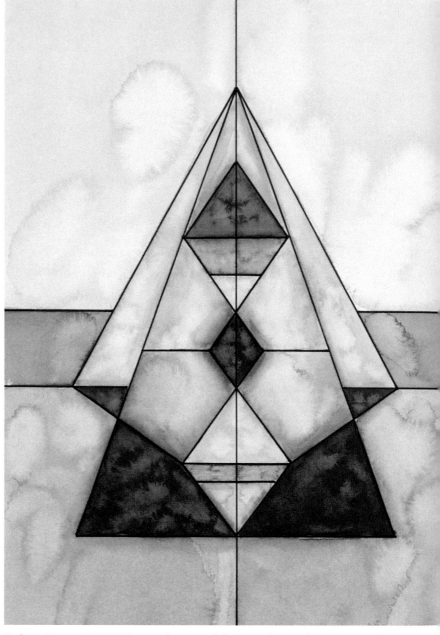

Marianne Brown, **ESCAPADE,** watercolor on 140-lb hot-pressed watercolor paper, 15 × 11" (38 × 28 cm).

5 FINAL TOUCHES. I found the quality of the colors too much the same, so at the edge of each, I added a light wash of the color next to it. Those mixtures brought subtle touches of green, purple, and orange to the painting. (Notice those blends on the "Palette Preview," which was a useful reference after all!) Introducing those changes softened the stark edges. Although this is a very balanced, static design, the color mixtures and textures keep it interesting.

other ideas to consider

Do your brushstrokes reinforce the thrust of your pyramidal motif? Check your painting for marks that are inconsistent. Do some shapes stand out because they are too different? Some brushstrokes may be in opposition to, or have too much contrast with, other marks on your paper. Change the direction of a stroke, wet the edge of a stroke, or change the value of a stroke to make it relate better to your design.

THINK OUTSIDE THE BOX

Does your triangular setup need to cover an entire sheet of paper? Could it be small and positioned off-center, with an interesting background filling the remaining space? Could your triangle be upside down? What happens if you draw a triangle multiple times, turning it in different directions each time? Can triangles be drawn one inside another? How about arranging any part of a triangle so it touches the top, the bottom, or one of the side edges of your paper?

TRY A COLLAGE

Design a collage using painted watercolor papers with the triangle as the basic structure. Move the collage papers around to find alternate ways of placing shapes so they wind up with a pyramidal framework.

BACKGROUND CONTRAST

A strong contrast between foreground and background will accentuate the pyramidal shape of your design. For example, foreground shapes painted in light values will pop out distinctly against a background of dark values. Or try the opposite: dark foreground shapes against a light background.

pyramidal designs

Erika Kunkel, CYCLMEN III, watercolor on paper, 19 × 26" (49 × 66 cm).
A floral arrangement with a tall, central stalk is a natural for a pyramidal design. Erika's free and easy handling of watercolor washes and her choice of rich, warm colors give this imaginative floral painting its lively look.

Masaye Nakamura, HARU, watercolor and collage on paper, 11 × 15" (28 × 38 cm).
Masaye's refreshing impression of flowers has a palette of warm cadmium red, permanent rose, and lemon yellow, contrasted with cool thalo blue and Payne's gray. Rice paper and other collage papers add texture and variety. Her wet-in-wet technique makes wonderful soft edges, and the darker values and brighter colors contribute to completing the pyramidal framework.

Daisy Hyer, UNTITLED, watercolor on paper, 22 × 30" (56 × 76 cm).
Daisy began by painting the yellow couch. When it was dry, she applied a layer of blue over the entire paper, which made the couch recede so the foreground figure, then painted with layers of graded washes, would be dominant. That dominance is reinforced because other objects have not been added to the composition. The unequal-sided pyramidal design contains and emphasizes the little girl as the center of interest. The curved rhythms in the dress repeat the other curved shapes in the painting.

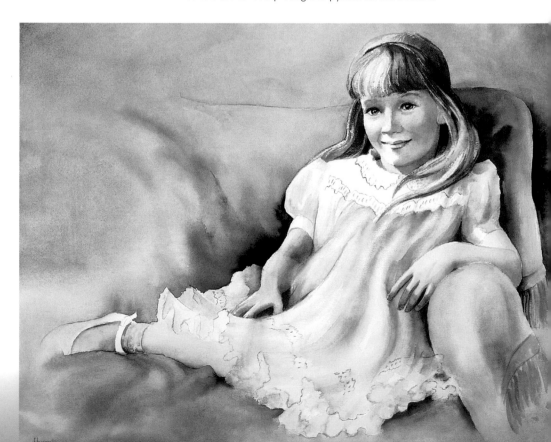

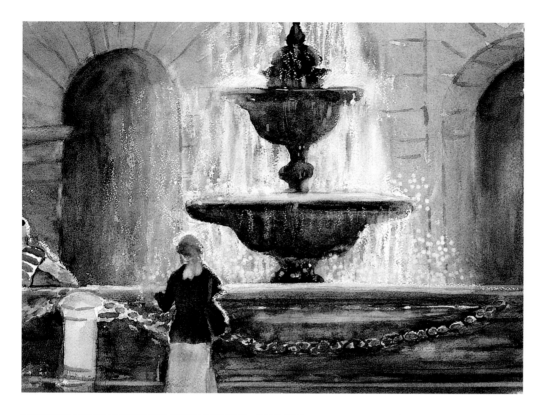

Bernard Johnson, THE FOUNTAIN, watercolor on paper, 11 × 15" (28 × 38 cm).

The shape of this fountain makes it a natural subject for a pyramidal composition. Bernard wanted to present a restful scene, which he achieved by using cool grays and blues. To get the whiteness of the cascading water, he rubbed a white wax candle on dry paper in those areas, which formed a textured resist to the paint. The rest of the scene was painted with graded washes.

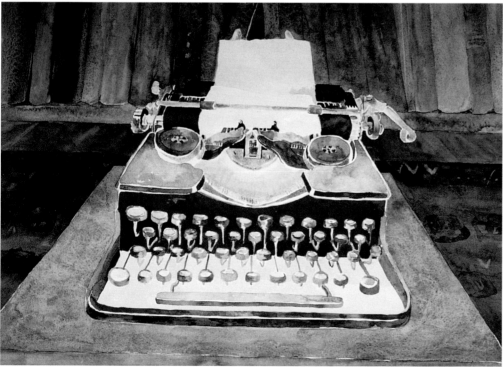

Elizabeth Rosberg, A SHIFTY FRIEND, watercolor on paper, 21 × 26" (54 × 66 cm).

The paper in the typewriter serves as the apex of the pyramid, and the front of the rug in the foreground gives it a strong horizontal base. Elizabeth used duller mixed colors for the background and clear washes of light values for her cleverly titled subject. A series of well-placed horizontals get smaller as they progress upward and add to the outline of the pyramid. Contrasts in values between watercolor washes add another valuable variation to the shapes, sizes, and color in the painting.

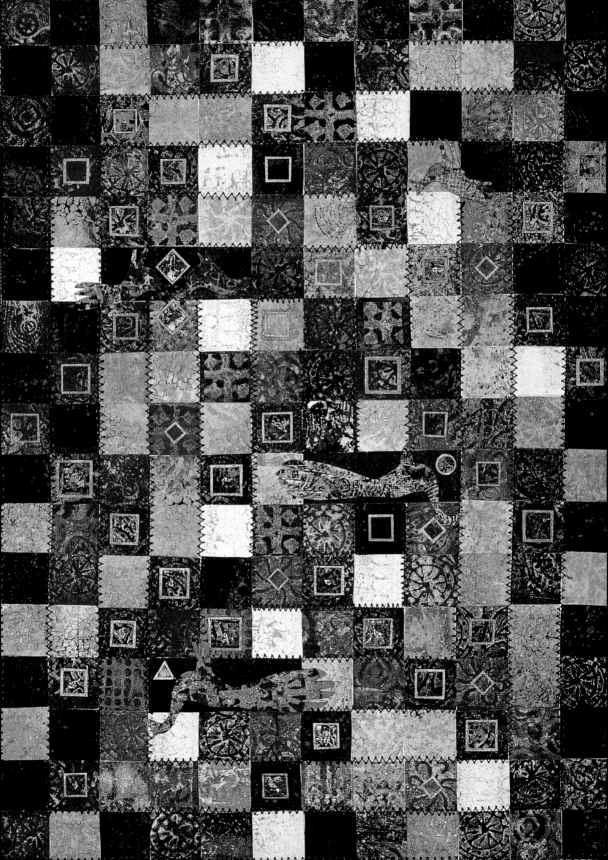

8
checkerboard
DESIGN

When painting a subject using a checkerboard grid as the basic design, your template is essentially an organized field of repeated squares of the same size. The purpose of using such a pattern is to create a peaceful, well-ordered painting.

Even if you have the checkerboard as a starting point, it may be hard to come up with an idea that suits that motif. "Art" doesn't just happen, even for very experienced painters. So if you're unsure of what to paint, consult your photo albums and

BASIC CHECKERBOARD-GRID DESIGN
Construction-paper collage, 8 × 12" (21 × 31 cm).

picture files. Turn to those clippings you've been saving of subjects that appeal to you that you've cut from magazines and other sources. Think about how to adapt them to a checkerboard motif.

Your grid doesn't have to be composed of many squares; an idea made up of only four equal quadrants is workable. Consider arranging a geometric shape in each square. How will you use color, line, and/or texture to develop a theme for that design? Will the mood be subtle and delicate or full of energy and power? Imagine alternating colors or leaving some squares unpainted. The use of some mixed colors and some clear colors can create a pleasing variation. Suggest depth by setting up a series of values and diagonals. Introduce a center of interest by contrasting values or adding a new color.

OPPOSITE Bea Jae O'Brien, BIRDS IN THE SQUARE, watercolor, collage, and white gouache on paper, 11 × 15" (28 × 38 cm). First, Bea Jae created painted and textured papers. Then, using stamps she had made, she impressed them on some papers for texture, and added layers of various paints to build more textural effects. With her papers cut and glued in place on a checkerboard grid, her painting took on a quiltlike pattern. She added birds for variety and visual delight, producing a work full of rich color and intricate textures.

PAGODA

I decide to make my painting with a square format to reinforce the perfectly square theme of the checkerboard design. All of the shapes will be geometric; colors and values will change, and fine lines will add texture. I may also include some white paper.

1 DRAW STRUCTURE. I drew a square grid (see page 18) and used it under my sketch paper for making various configurations of my idea. I judged the top left to have the best space divisions and truest representation of a checkerboard design.

2 PALETTE PREVIEW. When mixed with Payne's gray, my palette of cobalt blue, red rose deep, and raw sienna (on 22 × 15" paper) offers numerous subtle blends. Payne's gray is valued by many watercolorists as one of the most useful paints to have on hand as a component in building interesting, colorful neutrals.

3 TRANSFER DRAWING, SCORE LINES, APPLY FIRST WASHES. On a light box, I transferred my sketch to watercolor paper, using a 2H pencil for grid lines and the softer 2B for texture.

Next, I scored my dry watercolor paper along the grid lines, using a compass point (not too sharp, or it cuts the paper). Paint applied along scored lines created softer edges around each square.

With some masking tape, I blocked off two squares that I wanted to keep white.

After placing my watercolor paper on a dry bath towel, I wet the paper evenly with a 2" wash brush, painted light values of the first wash, and let it dry.

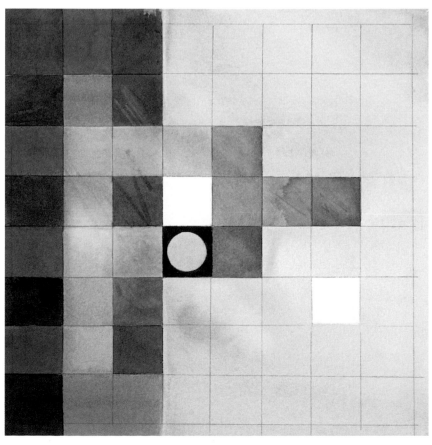

4 REMOVE TAPE, ADJUST VALUES. I warmed and pulled off the masking tape and clipped my dry paper to a drawing board. I adjusted the values. The light and medium values guide movement over the surface, while the circular shape and white squares offer short pauses on the visual trip around the painting.

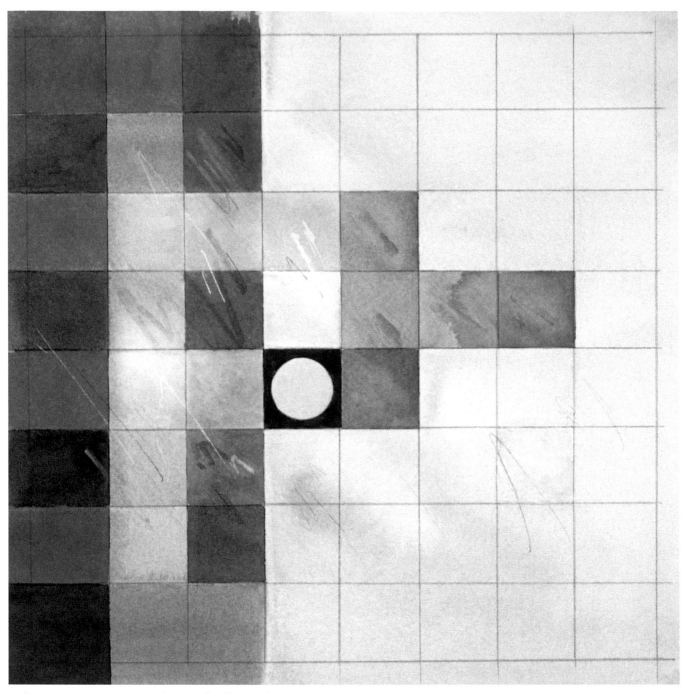

Marianne Brown, **PAGODA,** watercolor on 140-lb cold-pressed paper, 11 × 11" (28 × 28 cm).

5 FINAL TOUCHES. I included some texture with a sharp 2H pencil. I drew a few diagonal marks, then added short brushstrokes to echo the pencil marks. Finally, I thought the two lightest squares were too light, so I tinted them both with similar values.

other ideas to consider

Books devoted to standard quilt patterns provide good reference for paintings based on checkerboard designs. In addition to traditional geometric patterns, the squares may incorporate landscapes, figures, and animal motifs. Use such quilt patterns as a jumping-off point for your own approach to a checkerboard design that includes places and pets that have personal meaning for you.

THINK OUTSIDE THE BOX

Place your checkerboard grid inside another shape: a free form, a square, a circle, an oval, a triangle, or a variation of the rectangle. Try organizing bright colors, textures, or unpainted areas in your squared pattern. Draw your grid lines with colored inks, colored pencils, or crayon to act as a resist to your watercolor paints.

BALANCE INTEREST

If your idea is to place the center of interest in a corner or on the edge of the checkerboard, balance it with clever arrangements of color, values, and textures on the rest of the paper.

INVITE CRITIQUES

Mat your favorite paintings, and ask some artist friends to critique them. Suggest that they bring some of their work, and make this a reciprocal activity.

As they look at your paintings, write down their comments, and take the time later, when you're alone, to review their comments objectively. You may not agree with all of their observations, but you may hear some gems of artistic perception that you might never have come up with on your own.

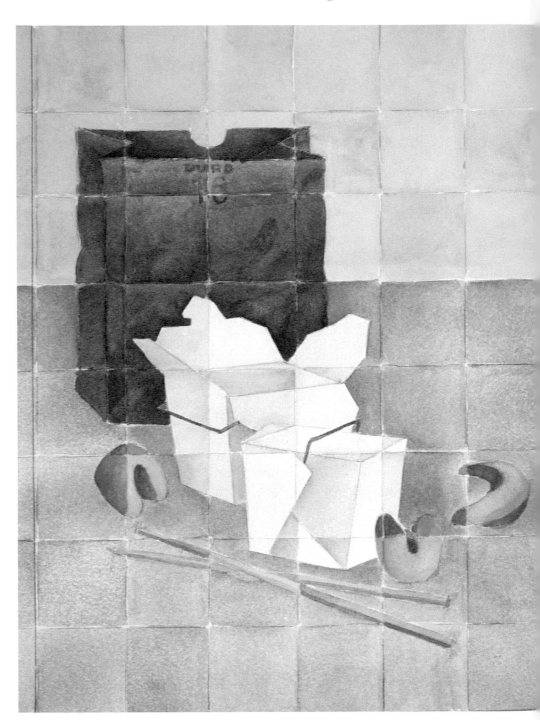

Marianne Brown, TAKE-OUT, (above) graphite on drawing paper, 14 × 10 1/2" (36 × 27 cm); (right) watercolor on paper, 14 × 10 1/2" (36 × 27 cm).

After transferring my sketch, I decided to paint each of the squares directly on dry paper. I revealed the checkerboard grid by changing the value of each color as it crosses a grid line. There is no expressed light source, only a pattern of light, medium, and dark color.

Jeanne Corse, SOMETHING NEW, watercolor on bristol board, 7 × 10" (18 × 26 cm).

Jeanne selected a painting she had made of an eggplant, and with a pencil, superimposed a checkerboard grid lightly on top of it. As she painted and changed the values in each square, her artwork became interestingly fractured and abstract. The smoothness of the board resisted the paint slightly, causing the "balloons"—another successful addition to her appealing work.

Barbara Falconer, STILL LIFE WITH GEOMETRY, watercolor on paper, 13 × 20" (33 × 51 cm).
Barbara drew her grid lines with a white Prismacolor pencil, which has an oil base that repels watercolor, causing the grid to remain white. Then she layered cobalt blue, burnt sienna, raw sienna, and yellow ochre on her dry paper. The light value in the diamond shape is appealing because it acts like a window. Through it, we may enjoy all the shapes, colors, and little stopping points where contrasts in values appear and intersecting lines draw our attention. This composition is also a good example of how curved shapes work well within a checkerboard design.

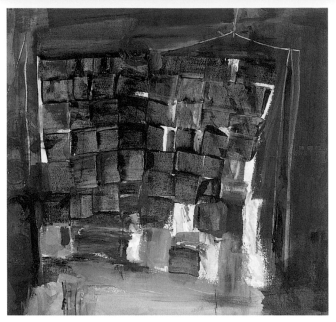

Mary Claire Stotler, **HOUSE OF CARDS,** watercolor on paper, 14 1/2 × 14 1/2" (37 × 37 cm).

This painting shows us an innovative and free interpretation of a checkerboard design. Mary Claire mixed thalo blue and cadmium red light into a unique color scheme. She pushed the paint around with a strip of mat board and created other textures by scratching out wet paint with the beveled end of a brush. Her grid is twisted and turned into the composition. The title gives viewers a hint as to the artist's fanciful thoughts as she designed her painting.

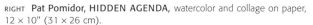

Mary Lucido, SPRING, watercolor on paper, 26 × 20" (66 × 51 cm).

Mary painted her checkerboard design by dipping a damp, square sponge into a puddle of mixed colors—aureolin yellow, sap green, and burnt sienna—and then carefully printing each square. An important step was measuring the squares and cutting the sponge precisely to size. She worked on Yupo paper, which has a very smooth surface on which paint can slip. To prevent that, she used a hair dryer on the paint before it could slide around. The subtle variation in color is a highlight of this handsome piece.

RIGHT **Pat Pomidor, HIDDEN AGENDA,** watercolor and collage on paper, 12 × 10" (31 × 26 cm).

Pat began with a monotype that she had created with zinc-white gouache, cadmium red, Payne's gray, and Andrew's turquoise. She liked the print, but wanted to try something new. A checkerboard theme was her answer. She cut the print into two-inch squares, rearranged the pieces, and glued them on heavy watercolor paper. Her aim was to create a mysterious look by using darker values at the bottom and lighter values at the top of her composition. She achieved her goal admirably.

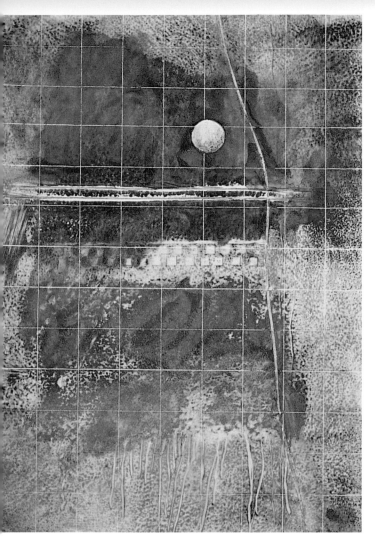

Tom White, EVENING MIST, watercolor monotype on paper, 13 × 10" (33 × 26 cm).

Experimenting with the printing process, Tom applied masking fluid on dry watercolor paper to block out his checkerboard grid and the moon for a monotype print. He created the monotype on a Plexiglas plate, using fuchsia, pearl white, blue, and Caribbean blue water-based airbrush paints. He scraped some lines and small squares out while the paint was wet. When the paint was dry, he printed this intriguing work on wet, hot-pressed watercolor paper by rubbing a spoon back and forth on the back of the sheet.

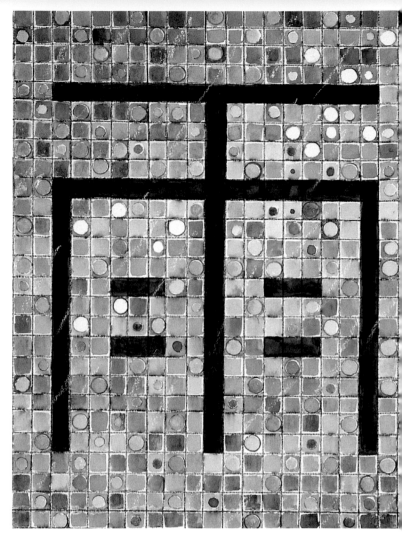

Amy Sum, RAIN, RAIN, RAIN, watercolor on paper, 14 × 10 1/2" (36 × 27 cm).

The Chinese symbol for rain, the theme of this painting, is the dark, dominant shape. Amy painted the remaining squares individually on dry paper. She applied Payne's gray mixed sparingly with lemon yellow and alizarin crimson to produce various values and textures that represent clouds, earth, vegetation, and light. The white diagonal lines suggest wind and rain, completing this cool, well-balanced checkerboard design.

9

asymmetrical
DESIGN

An asymmetrical-grid design is formed by using horizontal and vertical lines to make space divisions that produce varied rectangular and square shapes on the paper. The grid has a geometric order that unifies the objects in the painting.

Subjects such as windows, doors, walls, gates, and fences all have pronounced horizontal and vertical forms that work well in an asymmetrical grid. Also consider boat docks, aerial views,

BASIC ASYMMETRICAL-GRID DESIGN
Construction-paper collage, 8 × 12" (21 × 31 cm).

cityscapes, and arrangements of books or tools as subject matter. Interior scenes offer walls, furniture, and rugs with strong horizontal and vertical lines suited to this design concept, as do figures and still-life setups that are organized to fit this grid. Paintings built asymmetrically often have shallow space.

If you are more inclined to express yourself abstractly or nonobjectively in your watercolor art, asymmetry will lend an interesting order to your work. Include an assortment of values and textures. Investigate varied techniques. Make your grid lines more prominent by painting them in dark or bright colors against a lighter ground. Try these variations: painted grid lines that stop and start; graded washes that change to flat washes along grid lines; soft edges that change to hard edges along grid lines. All of these ideas can contribute to bringing added variety to an asymmetrical design.

OPPOSITE Irene Haney, FAT CAT, watercolor on paper, 22 × 15" (56 × 38 cm).
A cat looking out a window is placed in an asymmetrical-grid composition. Irene let her cat's colors determine the painting's warm color dominance. The tilt of the cat and the wonderful curve of its tail serve as contrasts to the straight-sided forms in the room. Concealing the animal's face adds to the painting's intriguing story, as viewers speculate on what is attracting the cat's attention.

VALLEY BARN

SUPPLIES

11 × 15" sketch paper

22 × 15" cold-pressed
watercolor paper

11 × 15" cold-pressed
watercolor paper

monotype base liquid

bath towel

pencil

light box

round brushes nos. 6
and 12

three tube watercolor
paints

I chose my subject for this demonstration from a series of photographs I had taken of barns and buildings in the central valley of California. (When photographing, if you see a subject you would like to adapt to a design motif, move your camera around until you find the desired space divisions. You might combine subjects from several photos to complete your plan.)

1 DRAW STRUCTURE. As I made these sketches and several more, I kept my photo reference nearby to remind me of the things I enjoyed most about the scene. I took the liberty of adding other shapes that would enhance my asymmetrical design, as shown in the drawing I chose (top left) for transfer to my watercolor paper.

Tip
COATING WATERCOLOR PAPER

Try coating your paper with any of these water-soluble products: monotype base; gum arabic; liquid starch; thinned, pure liquid soap; a permanent coating of acrylic matte or gloss medium; or white glue. Thin the permanent coatings and try using several layers. Paint on wet or dry coatings; rinse brushes well. These coatings make it easy to lift color off dry or wet paper with a wet brush, sponge, or tissue.

2 PALETTE PREVIEW. Although I chose a palette of three primary colors—manganese blue, cadmium red light, and yellow ochre (on 22 × 15" paper)—you can see how many muted mixtures these bright pigments can produce, many of which will be more appropriate for my realistic outdoor scene than the unblended colors.

Tip
FLOPPY BRUSH

Sometimes it's fun to use a big, soft mop or hake brush for the beginning wash. A wash applied with one of those will look different from a wash applied with a flat brush. It will lay down a freer, looser, more extensive wet wash because it holds more water.

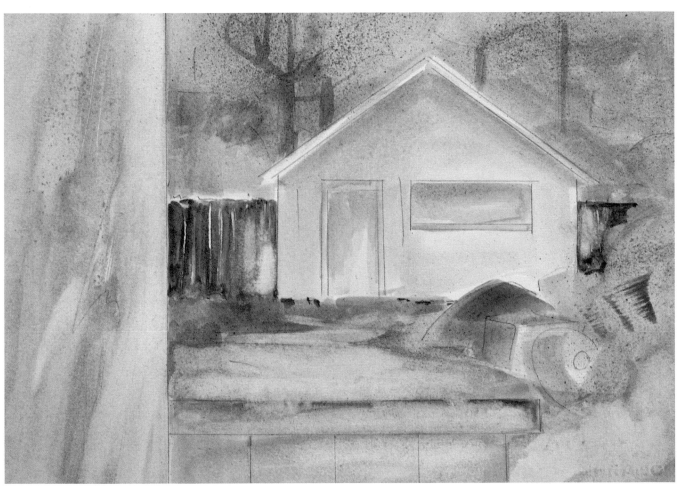

3 TRANSFER DRAWING, COAT PAPER, APPLY FIRST WASHES. Using a light box, I transferred my drawing to watercolor paper. With the paper clamped to a board to keep it flat, I coated the surface with one layer of monotype base, and let it dry.

I placed the paper on a dry bath towel and applied the first washes, balancing the warm and cool blends. These washes begin to define the dark and light values in the work, and the manganese blue granulated nicely, contributing textural effects. I let the painting dry.

4 ADD PAINT, ADJUST VALUES. I developed more definite patterns and details by adding paint in some places and lifting colors in others to create textures and shadows. Although I still referred to my photo references, the window and door pictured there were very dark areas, which would have given too much contrast to those parts of my painting, so I lightened those values.

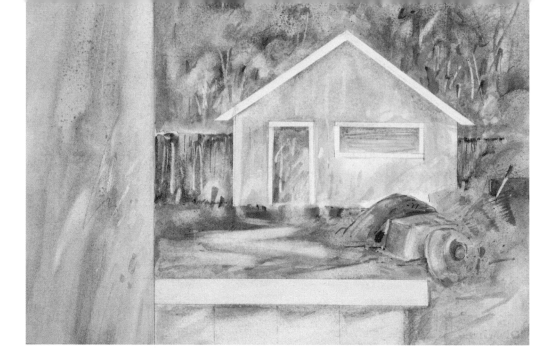

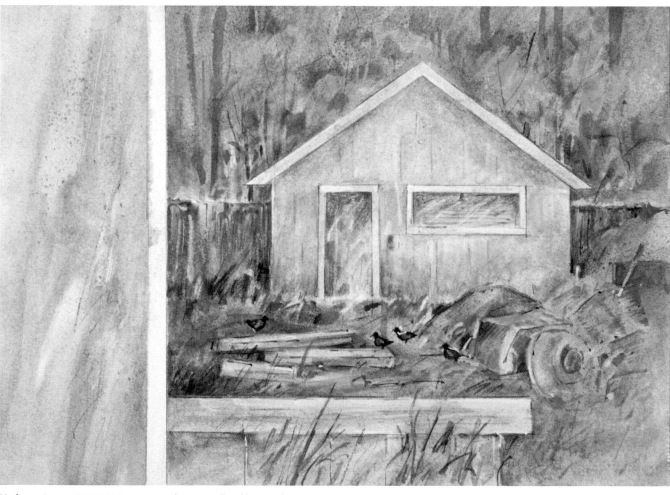

Marianne Brown, VALLEY BARN, watercolor on 140-lb cold-pressed paper, 11 × 15" (28 × 38 cm).

5 FINAL TOUCHES. After adding details in the grasses and foliage, I changed the brown fence color a bit, lightened the vertical edge on the left building, and painted a few blackbirds to bring a little life to the scene. The overlapping shapes in the otherwise flat pattern add a bit of depth. The varied structure of this asymmetrical grid organizes the placement of all the subject matter.

other ideas to consider

If you usually orient your paper vertically, try a horizontal direction; if horizontal is your general format, work vertically next time. Try sketching your asymmetrical grid in a square, a circle, a triangle, or in different configurations of a rectangle.

THINK OUTSIDE THE BOX

Arrange the asymmetrical grid in new ways. Try using only three unequal divisions, or sections, on your paper; include some squares in the grid; add a few diagonals; use more horizontal lines and fewer vertical lines (or vice versa).

FRESH FLOWERS

If you usually paint flowers in a formal, realistic style, add a realistic structure as a grid for your composition. With garden flowers, include a trellis or the side of a wall to form the asymmetrical grid. Have an arrangement of raised beds or rows of flowers follow the shape of your grid.

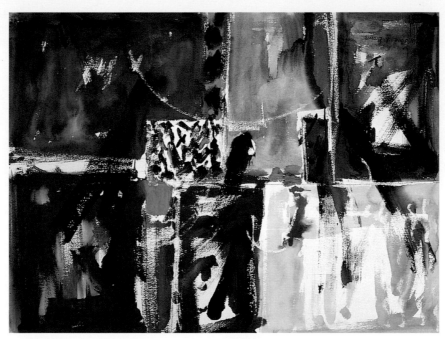

Marianne Brown, **SCOTT FREE,** watercolor on paper, 22 × 30" (56 × 76 cm).
The fact that we read from left to right can be important when planning a painting. Turn this painting around. Do you have an uncomfortable feeling seeing it upside down? I do. With lighter colors on the left, my eye moves swiftly past them, drawn to a strong wall of bright color on the right. But right-side-up, after seeing the dark areas on the left first, my eyes move on to enjoy the rest of the shapes and textures in this asymmetrical work.

asymmetrical designs

Marianne Brown, EGGPLANT, watercolor on paper, 11 × 15" (28 × 38 cm).

This painting is defined by its flat color and contrasting shapes— the curves of the eggplant with the straight-sided grid lines. I painted each section of my grid on dry paper. I chose the complementary color scheme of violet and yellow and used a no. 6 round brush with a good point that reached nicely into the corners.

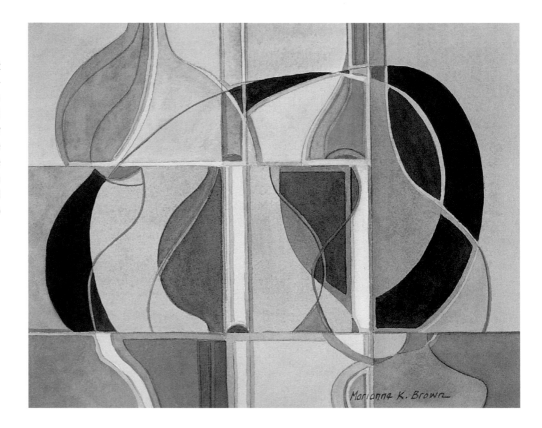

Robert Shaw, VIEW INTO A WARM ROOM, watercolor on paper, 8 × 10" (21 × 26 cm).

Robert began by blocking out many rectangular shapes with masking tape. When applying color, he balanced the large red shape with the pink tints, red lines, and smaller red shape. All the other colors and their values play an important part in defining the asymmetrical grid in this attractive, abstracted interpretation of various objects in a room.

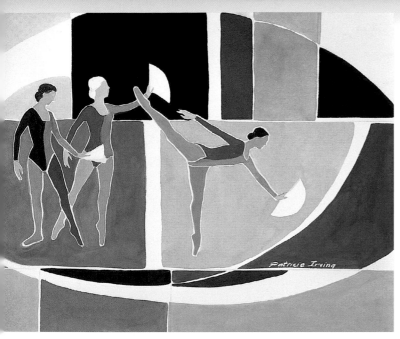

Patricia Irving, DANCER WITH FAN, watercolor on paper, 11 × 15" (28 × 38 cm). Patricia's idea was to portray the three steps in a dancer's progression to an arabesque. The oval shapes repeat the curved shapes of the figures, and the grid and balanced colors reinforce the asymmetric structure. This well-planned painting has good color and temperature contrasts that contribute to its crisp, clean look.

Victoria Sheridan, CITY, watercolor on paper, 11 × 15" (28 × 38 cm). This delicate, wet-in-wet painting features grayed colors that cast a misty aura over the scene. Victoria's softly blended edges add to the impression of dampness. All of the components are skillfully arranged in an asymmetrical pattern, with graded washes adding further unity to the work.

Camille Young, TANGERINES AND DOLL, watercolor on paper, 22 × 30" (56 × 76 cm).
This simple asymmetric grid has three unequal rectangles. The doll and vase are well-placed verticals, and the tangerines lead the viewer's eye into the painting, using a curve as a contrast to the strong horizontal and vertical divisions. The textures Camille fashioned with her fine brushwork are especially appealing, and her inclusion of a patterned wallpaper in the background lends added interest.

MONET

DEGAS

HENRI DE TO...

LAUTREC

aristide
BRUANT

dans

son cabaret

La Goulue

L. MISTRETTA

staggered
DESIGN

The staggered grid is usually formed with slight diagonals, as shown at right. If you plan to make strong diagonals, balance them with counteracting diagonal lines or shapes. The tension created between diagonals is described as informal compared to grids built with more formal horizontal and vertical divisions.

When unifying a painting using this grid as a starting point, as you add subject matter, think about letting some shapes overlap and interweave

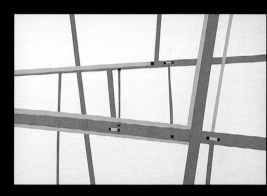

BASIC STAGGERED-GRID DESIGN
Construction-paper collage, 8 × 12" (21 × 31 cm).

on your paper. The grid may be very noticeable or partially hidden by the shapes of objects. Horizontal and/or vertical divisions may be added to settle down the inherent vitality caused by multiple diagonals. Angular and rounded shapes and lines may be included, but the staggered grid should remain the dominant structure.

As you plan your staggered grid, do simple drawings as well as some with many space divisions. Does the grid pattern remind you of anything? Part of a quilt, streets on a map, fields in a landscape, stones in a quarry, or a confusion of signs along a busy street are possibilities.

If you usually paint from nature, consider abstract or nonobjective subjects for this design motif. If you are inclined to cover your paper densely with color, you might try a more sparse distribution this time, leaving lots of white paper. Use your imagination. Take your time.

OPPOSITE Lorna M. Mullick, FUN WITH CLAUDE, HENRI, AND ÉDOUARD, watercolor on paper, 22 × 15" (56 × 38 cm). Lorna sketched directly on watercolor paper, then taped each area before applying paint. Notice her subtle lost-and-found diagonal grid lines, and how white and other light areas are balanced with darks. All the different sizes, shapes, and colors give this work its enjoyable, lighthearted feeling.

FRAMEWORK

SUPPLIES

15 × 11" sketch paper

22 × 15" hot-pressed
watercolor paper

15 × 11" hot-pressed
watercolor paper

pencil

light box

masking tape

hair dryer

¹/₂" flat brush

two tube watercolor paints

My staggered design is based on diagonals that have a slight slant, with some diagonals overlapping others. The background will remain unpainted paper. To reserve the white of those areas, I'll use masking tape to block off the foreground shapes and paint them separately between the taped areas.

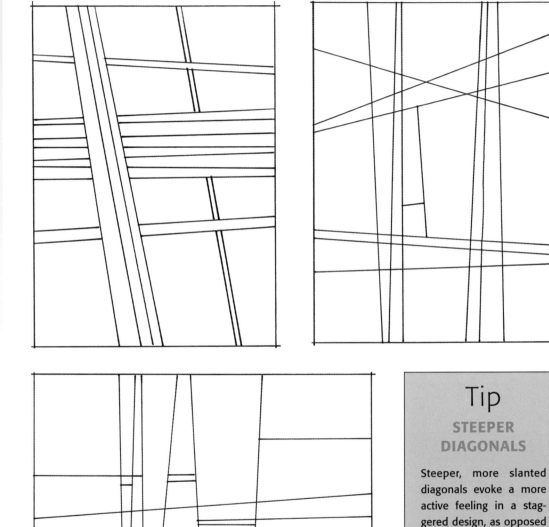

Tip

STEEPER DIAGONALS

Steeper, more slanted diagonals evoke a more active feeling in a staggered design, as opposed to the calmer feeling that slight diagonal relationships confer.

1 DRAW STRUCTURE. As with all the design grids in earlier chapters, for my staggered motif, I made many sketches, some in a vertical format, others, horizontal. A vertical format became my favorite, so the first (top left) is the drawing I chose for my painting. I find that its slight diagonals give the composition a calm quality.

2 PALETTE PREVIEW. I chose only two paints (on 22 × 15" paper) for my staggered design, but look at how many color possibilities result when mixing this pair of complementary pigments: alizarin crimson and thalo green.

3 TRANSFER DRAWING, APPLY MASKING TAPE, PAINT FIRST COLORS. Using a light box, I traced my sketch on watercolor paper, then placed my paper on a drawing board.

Next, I taped along the edges of the sections to be painted first, and applied the color between the tapes. At this point, the white diagonal strip that I intend to save is under the masking tape. (The tape extends off the paper and sticks to the board to hold the painting in place while I paint.)

4 CONTINUE MASKING AND PAINTING.
I masked each area separately and painted between each of those taped sections while referring to my "Palette Preview" to choose color mixtures and values. I left one diagonal line unpainted to balance with the white background. The ½" flat sable brush produces nice flat washes, which I dried with a hair dryer on a low setting. In some places I repeated the same color over an area to get a darker value.

Tip
SECURING MASKING TAPE

When masking off an area to reserve white paper, press the tape down firmly with the edge of a fingernail to prevent paint from leaking through when applying washes in areas between the pieces of tape. Warm the tape with a hair dryer before pulling it off.

Marianne Brown, **FRAMEWORK,** watercolor on 140-lb hot-pressed watercolor paper, 15 × 11" (38 × 28 cm).

5 FINAL TOUCHES. After looking at the previous stage for a while, I decided that the top diagonal was too steep and not in rhythm with the rest of the work, so I added the other diagonal shape below it. The shapes seemed fine now, but I was bored with the static arrangement. That prompted my adding the little dark triangle at upper right (after cutting out triangles of different sizes and moving them around the paper). My aim was to use close color values and to emphasize contrasts between the grid and background.

other ideas to consider

Textures can enliven a dull design. For varied effects, drop grains of table salt or rock salt on a wet wash; stain colors work best with salt. Place crumpled plastic wrap on a wet wash and let it dry in place, or even better, make layers of texture with this technique (be sure each layer is dry first). Consider spattering paint with an old toothbrush on wet or dry paper or washes.

THINK OUTSIDE THE BOX

Plan grid divisions in only one area of your painting (such as using five inches on the right side of your paper), and balance them with color, texture, or line. Where would you place one diagonal? Could you double or triple grid lines? How about placing grid lines emanating from the corners? Can grid lines be fashioned with crayons, pastels, masking tape, or scratch-outs?

ESTABLISH MOOD

Does your idea have a mood? Mood in a painting can be established with bright or dull colors or by moving your hand faster or slower when making brushstrokes or lines. Other elements that can suggest mood: soft or hard edges; the simplicity or complexity of a design; using lots of white paper; painting a dark background.

DEPTH

When designing space relationships, putting shapes that are larger at the bottom of the paper and smaller at the top tends to convey a sense of distance and depth.

Janet Loh, VARIATIONS, watercolor and charcoal on watercolor paper, 11 × 15" (28 × 38 cm).

Here, the staggered grid is defined by the dark shapes made with thick and thin lines that surround the colors. The viewer's eye is directed around the painting by the different bright and dark colors. Janet's geometric forms are designed in her own innovative way. The result is a strong and colorful work.

Almut Busch, TRAFFIC PATTERNS, watercolor and acrylic on watercolor paper, 14 × 20" (36 × 51 cm).

Almut began by putting strips of masking tape on her paper. As the white areas reveal, she used different widths of tape placed in different directions to reserve the white areas. When the tape was pressed down well to prevent leaks, she applied her paints, adding some textural effects by dropping water into the wet washes.

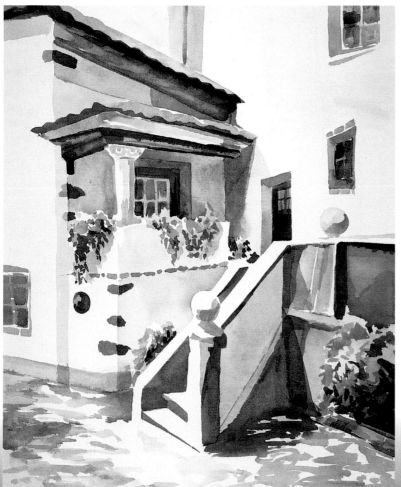

ABOVE **Marianne Brown, SUNDAY RIDE,** watercolor on paper, 15 × 22" (38 × 56 cm).

The basic structure of the staggered grid was my starting point as I developed this abstracted aerial view of a highway, off- and on-ramps, and road signs. I created the grid by changing the values of the land forms next to the highway, represented by the double black vertical strips.

LEFT **Anne Fallin, FRONT PORCH,** watercolor on paper, 22 × 18" (56 × 46 cm).

Anne's realistic painting of a lovely house is enhanced by the diagonals that define an interesting staggered grid. By using a muted palette and leaving so much of her paper unpainted, she allows the stark white ground to cast a sunny glow over the scene.

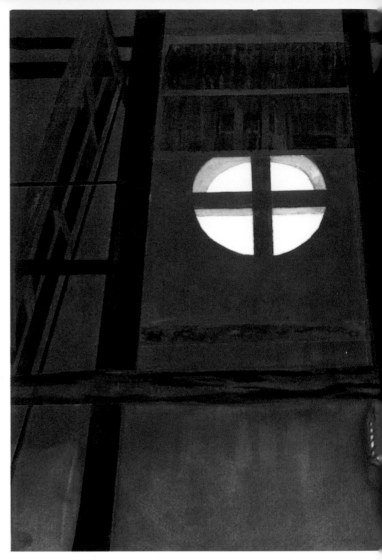

Marianne Brown, NIGHT FLIGHT 334, watercolor on paper, 30 × 22" (76 × 56 cm).

This is my impression of a night airplane flight over a sparsely lighted area. To represent roads, I blocked out lines with masking tape, and used masking fluid in a ruling pen for the thinnest lines. I chose Neutral Tint (a stain) as my dark pigment, leaving white areas for contrast. Textured areas symbolize a parking lot and various fields. I lifted-out squares for houses and for more roads between pieces of masking tape.

Joan Shimoda, SOLITARY, watercolor on paper, 15 × 11" (38 × 28 cm).

Joan's arrangement of her staggered grid gives an impression of depth. Although the painting is mostly bright red, it conveys a peaceful, ordered feeling. Masking tape was used to define the grid lines that hold the circle in place. The viewer may "walk" into the composition contentedly; the circular shape in the distance contributes to a sense of ease, suggesting warmth and protection as in a sacred space.

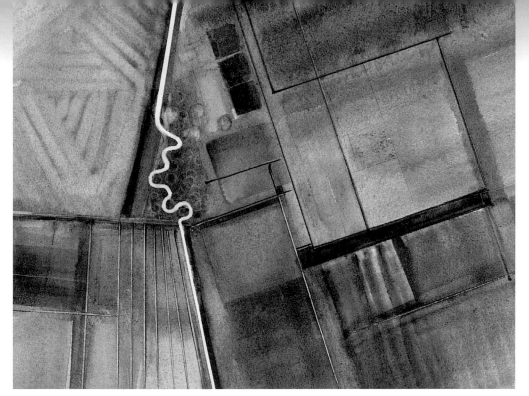

Vera Grosowsky, VIEW FROM THE AIR, watercolor on paper, 13 × 16" (33 × 41 cm).

This painting evokes for Vera her enjoyable experience of surveying land from an airplane window. The shapes representing fields are restful, with diagonals counteracting one another slightly. Varied cool greens are contrasted with warm colors that form an implied horizontal in the staggered-grid setup. This is a fine example of how horizontal movement can be added to any painting with color instead of with lines or shapes.

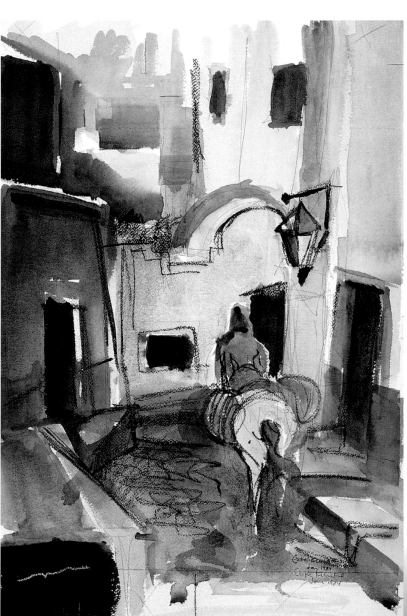

Erika Kunkel, STREET IN MEXICAN VILLAGE, watercolor and charcoal on paper, 21 × 14" (55 × 36 cm).

Erika used cerulean and ultramarine blue, yellow ochre, yellow light, cadmium yellow, and Indian red—the colors she had observed on a trip to Mexico. She applied her colorful, mingled watercolor washes on dry paper and added lines with charcoal pencils. The staggered grid is established by repeated diagonal shapes; curved shapes introduce interesting variations.

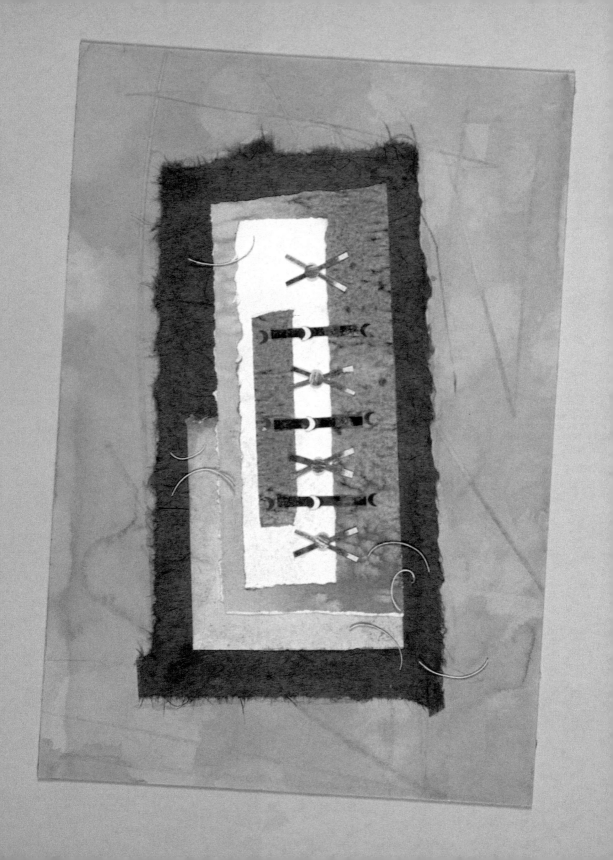

frame-in-frame
DESIGN

In the frame-in-frame design, the subject matter is enclosed by an outside border. The border can be dark or light and be painted in any combination of colors, values, or textures. Since the subject matter is fenced in, this scheme isolates objects and shapes from the edges of a painting. It is sometimes called "composing by closure." When subject matter is isolated in this way, the viewer is immediately drawn to the painting's center, where the most important things are happening. Therefore,

BASIC FRAME-IN-FRAME DESIGN
Construction-paper collage, 8 × 12" (21 × 31 cm).

the border should not detract from the subject if the focal point is to be maintained.

The frame-in-frame structure can also contain more than one border, as shown in my painting on the opposite page. Although mine is a nonobjective approach, numerous realistic subjects also lend themselves to a frame-in-frame motif.

The shape of a window is an obvious idea for a frame to isolate a scene outside a building. In an interior scene, a figure could be looking out of the window. If you like to paint animals, a dog or cat might be framed by a doorway or by a big boxy chair in which the pet sits curled up. Flowers can be placed in a framing box; other still-life setups may be developed with dark or light values in the background and foreground to form a frame. Finally, it bears repeating: All pictorial efforts benefit by using variations in size, color, value, and texture.

OPPOSITE Marianne Brown, FRAME-UP, watercolor and collage on mat board, 15 × 11" (38 × 28 cm). I started with two pieces of mat board, and painted the smaller one with a light wash of burnt sienna. Overlapping painted-paper shapes containing different sizes, colors, and values complete my frame-in-frame structure.

SUNSET CHARADE COLLAGE

SUPPLIES

11 × 15" sketch paper

22 × 15" drawing paper

11 × 15" colored mat board

miscellaneous collage papers

white glue

wet cloth

wax paper

scissors

pencil

ruler

I hope this frame-in-frame collage demonstration will stimulate your interest in working with paper and paste, especially if you are a watercolorist who has never tried this art form before. For a supply of collage papers, I save unsatisfactory paintings that offer varied colors and textures, along with papers of all kinds, that I cut and tear into the pieces I need for a collage.

1 DRAW STRUCTURE. Of the many sketches I made using a frame-in-frame structure, I chose my favorite (left) to guide the composition of my collage for this demo. But as usual, I saved the other sketches for possible future use, and soon put the vertical one (below right) to good use as the basis for another frame-in-frame composition (see page 86).

Tip
COLLAGE MATERIALS

Collage materials can come from numerous sources. In addition to saving and cutting up your less successful watercolor paintings, build your collection by clipping pictures that you admire from magazines and newspapers. Save greeting cards, postcards, wrapping papers, fabric swatches, beads, shells, string, and any other materials that appeal to you.

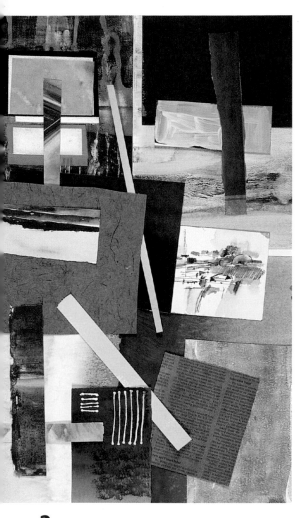

3 CHOOSE MAT BOARD, APPLY FIRST PAPERS. As the background for my collage, I chose a warm-colored matboard in a medium value to frame the two darker central shapes. Then I pasted light-colored papers on them. The horizontal bands were glued on to interrupt the background color and tie down the central shapes to keep them from floating in the composition. To press the papers firmly in place, I put wax paper over the collage with a weight on top of it for about an hour.

2 PALETTE PREVIEW. This sheet (22 × 15") shows many possible papers for my collage. They include painted watercolor paper, rice paper, pastel paper, wrapping paper, and some mat board. The papers are not pasted down at this point. I will make my choices from the varied values and textures of the warm and cool colors, and set aside some other pieces to use for contrast.

4 ADD MORE PAPERS, BALANCE PIECES. When the first glued layers were dry, I cut and tore medium-sized papers and moved them around until I found the best arrangement to balance colors, sizes, shapes, and values. Then I introduced slight diagonals for variation, and placed weighted wax paper over the collage again to let the glue dry.

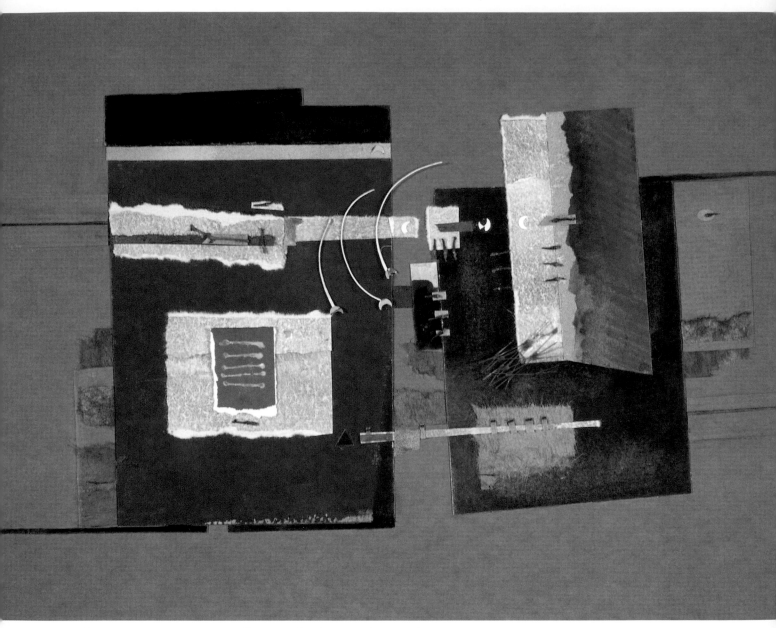

Marianne Brown, **SUNSET CHARADE,** collage on mat board, 11 × 15" (28 × 38 cm).

5 FINAL TOUCHES. I decided that the lines in the frame area were too wide, so I covered them with background color and included several thin paper lines. I added the three semicircular lines, which established the center of interest. Completing the collage with smaller pieces of color and overlapping shapes served to give a sense of shallow depth to the work.

Tip
TURN YOUR COLLAGE

Pick up your finished collage and turn it slowly in four different directions to see how colors, values, shapes, and lines are balanced. Study each direction carefully. With abstract or nonobjective art, you may find that the layout looks better oriented in a direction that differs from your original plan. Make that decision before you sign, mat, and/or frame your work for display.

other ideas to consider

The next time you visit a museum or look through fine-art books, see if you can find paintings where artists use the frame-in-frame structure to give more attention to the central area of a composition. Photographers also rely on this plan to emphasize certain subject matter. Studying the work of others is always an excellent way to find additional approaches to this or any design scheme.

THINK OUTSIDE THE BOX

If your frame-in-frame structure seems too static, ask yourself: Does the border need to be in the same width, color, and/or value all the way around? Does it need to be continuous? By opening up a border at any point, you can allow the viewer to enter a painting along its edges as well as at its center. Can there be double, triple, or multiple borders instead of one? Can your border be large and your subject small?

BALANCE MOVEMENT

Does your painting's path of vision direct the eye toward the border or off the paper? If so, it may be because an intense color or important shape leads the movement of your composition to the edge. What you may need is a counteracting movement, color, or shape to keep the viewer's interest centered on the subject.

PREVENTING PAPER FADES

When using mat board for a collage, take into account that some colored mat boards fade in time. To preserve their color and the color of any other papers that you fear may fade, coat your finished work with Krylon Clear Acrylic Spray, which is ultraviolet (UV) resistant. Always use the spray outdoors. Another way to prevent papers from fading is to use UV-resistant glass for framing your work.

Amy Sum, MOTHER AND CHILD, watercolor and ink on paper, 14 × 10" (36 × 26 cm).

Amy sketched the figures and outline of the framing shape directly on her watercolor paper. She painted the figures first, filled in the background, then outlined the figures with black Sharpie pen. That outline repeats the dark values in the frame area and brings balance to her painting.

Marianne Brown, UP TIGHT, watercolor on paper, 30 × 22" (76 × 56 cm).

I designed the border area in this painting with edges showing broken geometric shapes, then repeated some of the border colors and values nearby in the central area. My colors include mixtures of two blues (ultramarine and cobalt) and three reds (burnt sienna, English red light, and cadmium), painted with a combination of hard and soft edges and varied arrangements of line. Hard edges define the shapes; soft edges are contained within the shapes. I created textures by placing bubble wrap on top of wet washes and by adding various kinds of line.

ABOVE **Harriet Little, AUTUMN,** watercolor on paper, 15 × 21" (38 × 53 cm).

Harriet built two frames, left and right, into this painting. She applied her paint on wet paper and created textures by stamping with brushes and sticks. The fall colors and fresh, direct application of the paint suggest a bright autumn day.

LEFT **Tom White, STRUCTURAL GRID,** watercolor on paper, 14 × 14" (36 × 36 cm).

Tom cut thin strips of masking tape and placed them on his paper as a block-out for the checkerboard grid. He built his painting by layering transparent colors, and by placing plastic wrap on the wet washes to create texture. By painting the center grid with light values, he created contrasts with his framelike outside grid. The longer you look, the more variations you see in this composition.

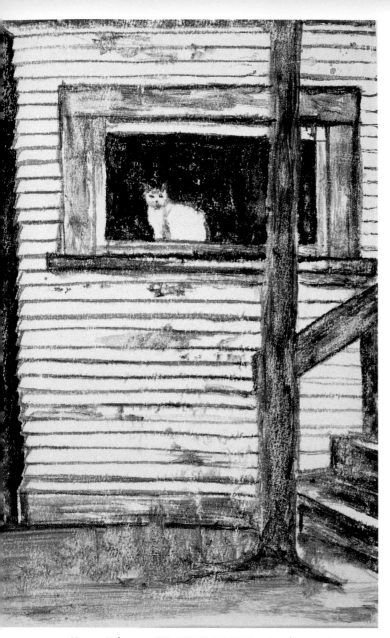

Masaye Nakamura, CAT IN THE WINDOW, watercolor monotype on paper, 15 × 9" (38 × 23 cm).

Good rhythms and textures are constant in this frame-in-frame structure. Varied vertical and horizontal shapes form the frame for the cat sitting in the window. Masaye's unusual textures on the paint were created in the monotype process.

Robert Dunn, ROCKS, watercolor and oil pastel on paper, 22 × 15" (56 × 28 cm).

Robert's rock shapes diminish in size as they recede, to suggest distance. He outlined the rocks with oil pastel, which also served as a resist for his warm and cool watercolor washes of raw sienna, burnt sienna, and ultramarine blue. The frame-in-frame structure is defined by the darker values applied in the composition's border.

Gail Riordan, YELLOW STAR, watercolor on paper, 10 × 10" (26 × 26 cm).

Gail sketched her checkerboard grid lines with pencil, then designed the star within the grid. Painting wet-in-wet, she used lemon yellow and Prussian blue as her color scheme and aimed for a tattered look as well as a shimmer for the star. The idea of designing a broken frame around the star is intriguing. The frame shape changes; the value scheme changes.

Helen Westcott, LIGHT AT THE END, watercolor on paper, 9 1/2 × 13 1/2" (24 × 34 cm).

Helen's painting shows the frame-in-frame design with multiple frames. Paper left as white line defines the rectangle. Additional white lines contribute direction and balance. Observe the varied values and intensities of the green color.

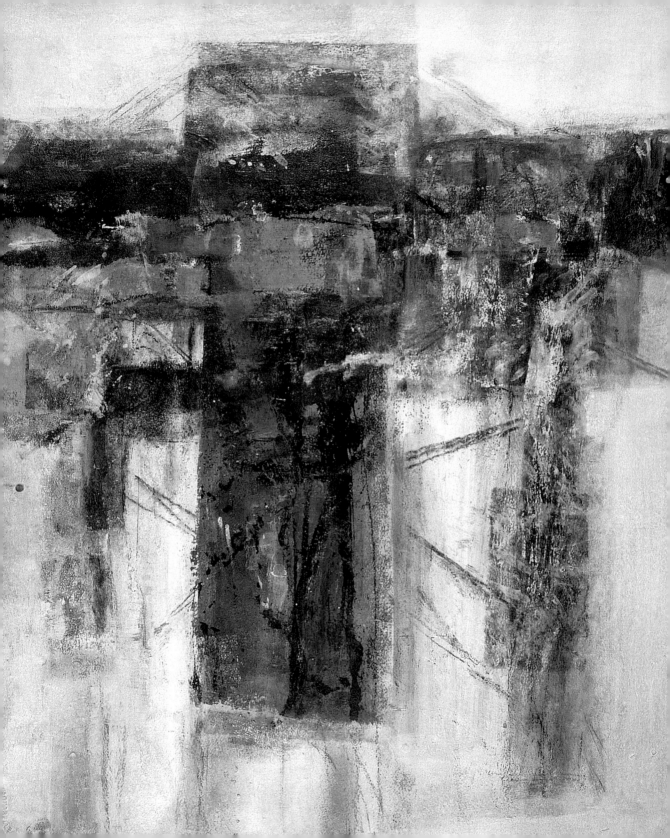

CRUCIFORM DESIGN

As its name suggests, the main structure of a cruciform design is the shape of a cross. The composition encompasses a horizontal, a vertical, and four corner boxes. When you design your subject, the shapes, techniques, and colors in the central area must balance with shapes, techniques, and colors in the boxes. If your central shape is too colorful and contrasts greatly with the corners, it will take over the composition and force the viewer's eye toward the center. On the other hand, if the boxes are more colorful and detailed, it will force the viewer's eye outward. You can plan a balanced cruciform design by using close values in the central shape and in the boxes.

Make a list of subjects shaped like a cross. Consider telephone poles; intersecting streets; an arrangement of doors and windows on a building's façade; a still-life setup arranged to form the cruciform structure. Place tall items as the vertical; smaller items as the horizontal. Find crosslike shapes in rocks, walls, and trees.

BASIC CRUCIFORM DESIGN
Construction-paper collage,
12 × 8" (31 × 21 cm).

If you enjoy painting figures, picture a diver or dancer with outstretched arms; place a tall figure on a hill silhouetted against a broad horizon line; or put a standing figure on a beach at water's edge, facing a horizon line where sea and sky meet. Create any of these cruciform designs by balancing shapes, colors, values, and textures in the center and in the corner boxes. Paint the boxes so they support the important central shapes and colors.

OPPOSITE Myriam Chapman, BRIDGING OVER, acrylic on paper, 22 × 27" (56 × 69 cm).
Myriam mixed violet, blue, yellow, and brown fluid acrylics on her paper, then pushed her colors around with a brush. She applied thinned white gesso in the background corners, and painted the image of a bridge in the horizontal axis last. Light areas in the background give your eye a place to rest before going on to enjoy the uneven textures and varied values in the rest of the cruciform composition.

CITY PARK

SUPPLIES

11 × 15" sketch paper

22 × 15" hot-pressed watercolor paper

11 × 15" hot-pressed watercolor paper

light box

black Sharpie pen

round brushes nos. 10 and 14

three tube watercolor paints

table salt

piece of stiff fabric

I plan to base my cruciform design on straight-sided geometric shapes. To add interesting textural effects, I will drop table salt into the wet washes (see "Tip" below).

1 DRAW STRUCTURE. After trying many possible arrangements for my cruciform design, of my three top choices, I settled on the first (top left).

Tip
SALT IMPARTS TEXTURAL EFFECTS

Sprinkle salt on wet paint. As the wash dries naturally, the salt moves the paint. Washes containing more water produce more varied configurations. For other variations, drip the salted washes faster or slower. Remove all the dried salt with a stiff material, such as rolled-up nylon netting. Some of the paint color will be absorbed into the dried salt. Save and use the salt a second time; the remaining color will melt into your next wet wash. To make layers of salt textures, be sure your paper is dry between applications of paint and salt. Try different kinds of salt: table salt, kosher salt, sea salt, rock salt.

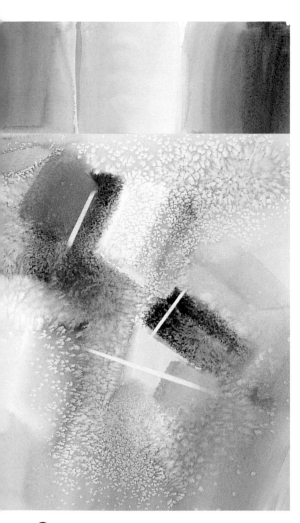

3 TRANSFER DRAWING, APPLY FIRST WASHES AND SALT. I put the 11-x-15" watercolor paper on my light box with the sketch under it, traced my design with a pen, and added diagonals for variation. Next, I clamped the paper to a board and applied each color separately, using both round brushes. Before each color dried, I sprinkled on slight amounts of salt, and let the paper dry naturally.

2 PALETTE PREVIEW. On 22-x-15" watercolor paper, I experimented with many possible mixtures of my chosen colors—thalo blue, Naples yellow, and thalo green—with salt sprinkled into the washes to observe textural effects. I checked the lifting quality of my colors by lifting with water and a stiff brush between two pieces of masking tape. (The several white lines are the areas where paint was lifted.)

4 REMOVE SALT, ADD MORE WASHES. Once the paper was dry, I removed the salt with a piece of nylon netting and continued painting—often checking my "Palette Preview" for color and value guidance. I sprinkled salt into the wet paint as I developed each area. The texture didn't show up as well in the light-colored shapes, so I painted and salted them again to adjust and balance colors and values. After each area was dry, I removed the salt. I liked the texture, and the four corners did not attract attention away from the central cruciform shape. The painting was finished—but I had another idea.

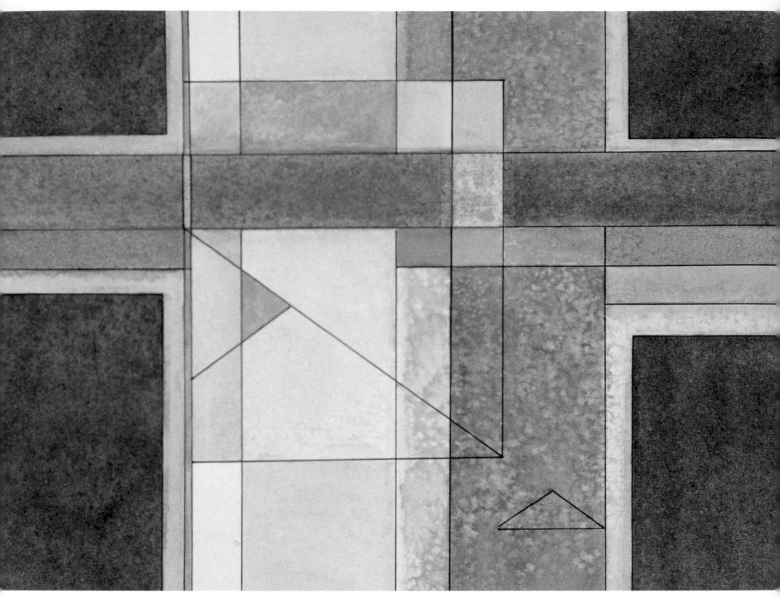

Marianne Brown, **CITY PARK,** watercolor and salt on 140-lb hot-pressed watercolor paper, 11 × 15" (28 × 38 cm).

5 FINAL TOUCHES. I wondered how the design would look if I changed the corner boxes to a darker value. After I did so and re-salted those areas again, I let everything dry and removed the salt. Now the cruciform shape is more definite, and the painting technique is unified by the salt texture in all the washes. The balanced values keep the work nice and flat. My new idea is completed. Use your own judgment about which version makes the best cruciform painting.

Tip
CURVILINEAR SHAPES

A combination of straight lines and curves can bring interesting variations of shapes and patterns to a cruciform design. The central portion of the design that defines the cruciform may have straight-sided shapes, slightly curved ones, or a mixture of the two.

other ideas to consider

If you like to paint landscapes, although they are not as readily adaptable to a cruciform motif as abstract and nonobjective subjects, there are ways to do it. Use the horizon line as your horizontal axis, with tall trees forming the vertical axis. Clouds, mountains, lakes, and flocks of birds offer other shapes that might be worked into the cruciform structure.

THINK OUTSIDE THE BOX

Do the lines forming the cross need to be parallel? Could you create a cruciform design by changing the value or intensity of color between the boxes and central shape? Can your cruciform be painted with soft edges? Hard edges? Perhaps alternate soft and hard edges? How about defining some areas with flat color and others with texture? Could parts of the cross be narrow and other parts wide? What happens if you accent either the horizontal or vertical bar of the cross? Does the cross shape need to be in the center?

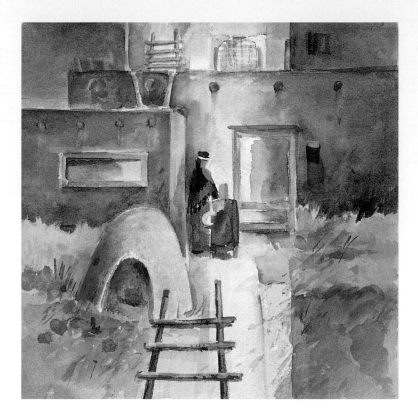

Marianne Brown, PUEBLO, watercolor on paper, 8 1/2 × 8 1/2" (22 × 22 cm).

Using a photograph as reference, I altered the scene to adapt it to a cruciform design. First, I placed the figure and other details in the central vertical axis of a cruciform shape. I painted values in the desert plants and foreground sand lighter than they were in my photo to emphasize the horizontal bar of the design. The arrangement of the values gives the effect of early morning light coming through the opening between the pueblo buildings.

cruciform designs

Marianne Brown, CITY, watercolor and pastel on paper, 22 × 30" (56 × 76 cm).

Working on wet, rough-textured paper, I drew the lines representing buildings, windows, and signs with soft pastels, which melted and blended on the wet surface. I established the cruciform design with line in a quick, lighthearted way. Before the paper dried entirely, I painted small watercolor washes in selected corner and central areas.

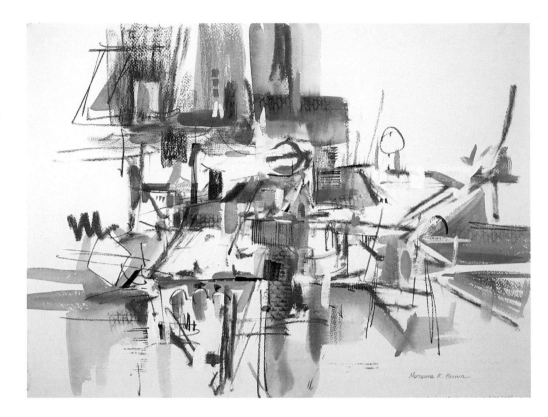

Janet Loh, CROSSING LIGHT, watercolor and watercolor pencil on paper, 18 × 20" (46 × 51 cm).

Janet's wet-in-wet painting is a simple statement that includes sensitive lines made with watercolor pencil before the washes on her paper were dry. She used red rose deep, cobalt blue, and a dominance of various values of yellow ochre to convey an aura of light.

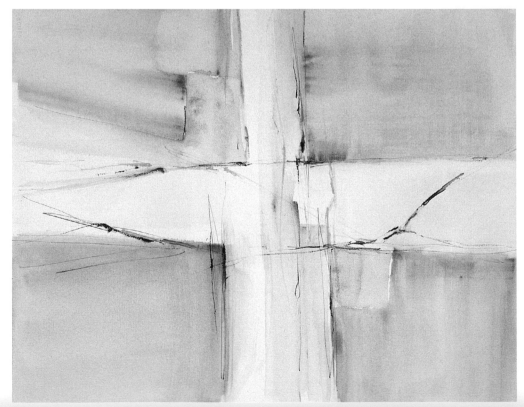

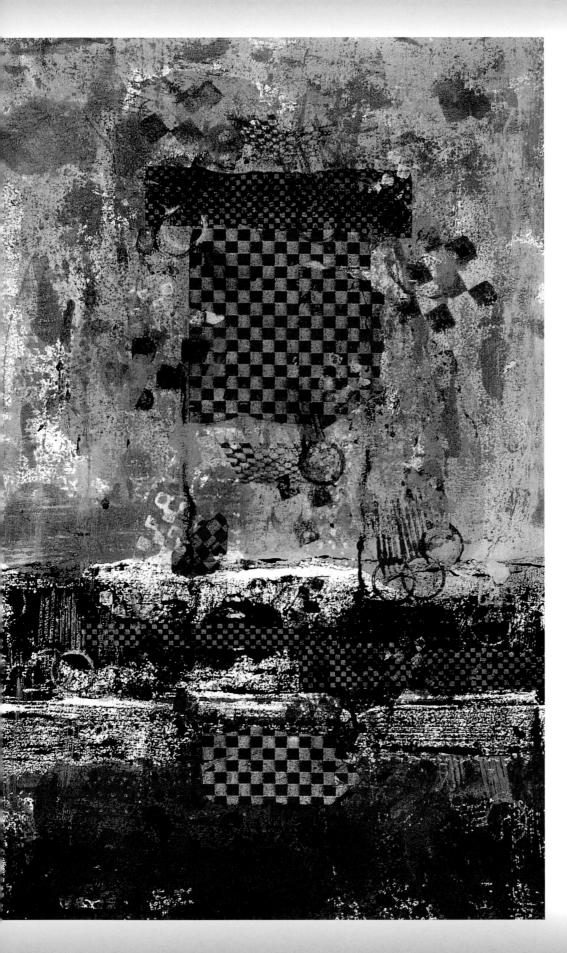

Diane Goldstein, MONOTYPE III, acrylic and collage on paper, 19 × 12¹/₂" (40 × 32 cm).

Diane painted her cruciform design on a sheet of Plexiglas, then printed the wet art on dry paper. Each step of the monotype process with acrylic paint involves taping the printing paper down on one side, and then flipping it to allow the paint to register properly. Each time she flipped the paper to the plate, she printed the color by rubbing the back of the paper with a spoon or her hand to achieve different textures. When the paint was dry, she added some collage and used various stamps and colors to create more textures. Her lively color scheme includes quinacridone crimson, magenta, Indian yellow, Payne's gray, and white gesso.

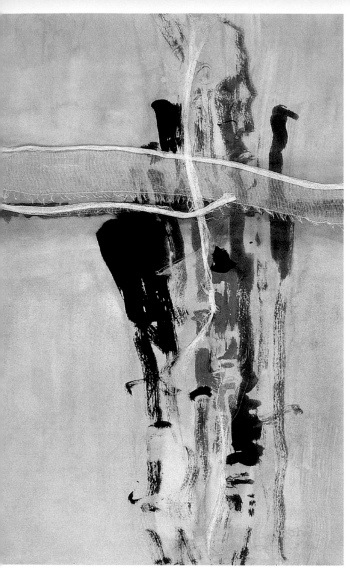

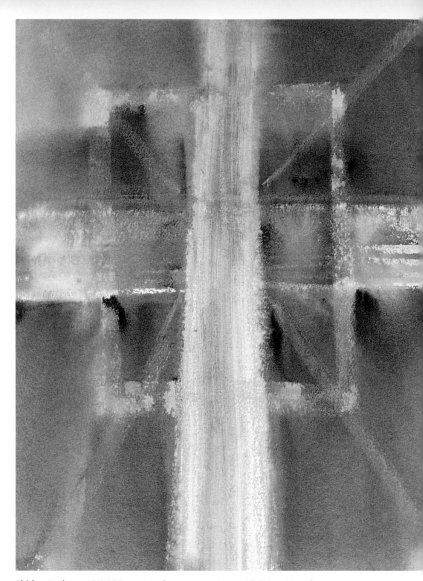

Lawrena Soh, DRIFTING, watercolor on paper, 22 × 15" (56 × 38 cm).

Lawrena used a light wash of thalo blue and ivory black to define the cruciform structure in this painting. She applied her paint with cheesecloth and dry brushstrokes to create the textural effects. Notice how innovatively she used different values of her colors to form the uneven vertical shape of the cross.

Shirley Burkart, UPWARD, watercolor on paper, 16 × 12" (41 × 31 cm).

This is a fine example of a wet-in-wet watercolor technique exhibiting a dominance of soft edges. The few hard edges define space divisions that appeared on the paper as it dried. The cruciform is the basic structure, with other shapes added to complete the painting. Shirley's idea of using pastel colors and some radiating lines to give the work a spiritual feeling is successful.

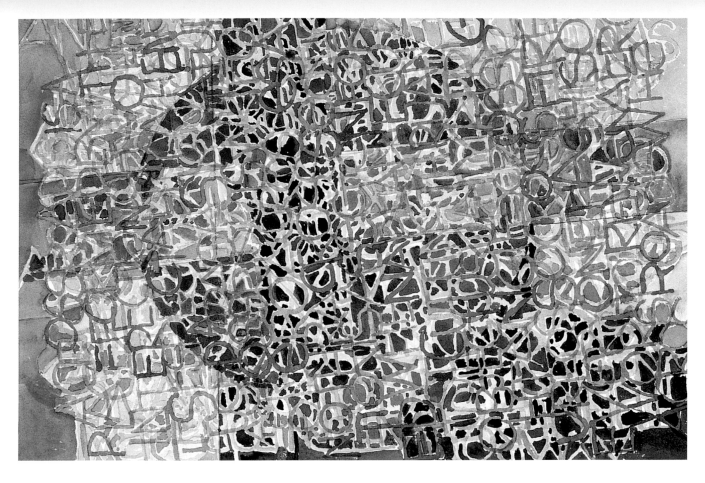

ABOVE **Vera Grosowsky, RAVENNA,** watercolor on paper, 13 × 20" (33 × 50 cm).

Vera was inspired by the mosaic floors in Byzantine tombs near the city of Ravenna, Italy. She painted the central cruciform shape with a small brush on dry paper. To create the texture, she wrote words she was thinking about, and then overlapped other words in different colors. Then she added the circular shape around it. She continued by adding background shapes with values that allowed the cruciform shape to stand out. Her palette has a warm-color dominance. The texture is unique and the values are subtle in this fascinating painting.

Edith Yu, UNDERCURRENT, watercolor on paper, 15 × 22" (38 × 56 cm).

Edith's idea was to paint a seascape with neutral mixed colors. She created the horizontal undulating lines by applying masking fluid in a ruling pen on dry paper. When the fluid was dry, she painted Payne's gray and lemon yellow wet-in-wet to form the background wash. After that had dried, she removed the masking fluid, leaving the white lines. Wonderful rhythmic movement and mixed colors symbolize the water and waves. The dark vertical line imparts an impression of depth.

13

cantilevered

DESIGN

In architectural terms, a cantilever is a projecting beam supported at only one end. In artwork, the cantilevered design displays shapes that project out into space and are anchored or supported on one side by a color, shape, or subject. The weight in the two areas should be balanced; that is, the impact in one area needs to be in visual equilibrium with the other area. Use color, values, textures, and shapes to balance the two parts, but keep your focal point on the projected form. The supporting

BASIC CANTILEVER DESIGN
Construction-paper collage, 8 × 12" (21 × 31 cm).

shape may be placed in any corner or toward the top, bottom, left, or right edge of your paper. The rest of the subject projects into the remaining space.

Your cantilevered design may be built around a single mass, a single object, or groups of objects. Figures, animals, landscapes, cityscapes, and still-life setups are all candidates for subject matter. Imagine a seated woman, arms down to the side, with her head and torso as the anchor on the left side of the paper, and her legs stretched out as the projecting form. A dog as a projecting shape can be arranged on an anchoring rug. Create an aerial view of a large land mass as the anchor and a peninsula jutting out into the water as the projecting shape. Plan a still life with a larger object on the left as the anchor and the remaining objects projecting to the right.

In planning a cantilevered design, the most important thing to remember is that the focal point should be in the projecting shape. Paint new or brighter colors, more detail, new shapes, or greater contrasts to catch the viewer's eye.

OPPOSITE Carol Jurasin, ORANGES IN DEPTH, watercolor on paper, 15 × 11" (38 × 28 cm).
Carol contemplated showing subject matter in a mirror. She developed her idea using oranges and eggs, revealing their twists and turns as they recede into the shape of the mirror. Her perceptive, innovative approach shows the repeated shapes cantilevered from the anchoring group in the foreground.

MAINE COAST

I decide to paint an inlet with its projecting point of land, using reference photos of many such scenes that I had enjoyed on a trip through Maine. My plan is to have the projecting landform anchored on the left side of my paper, and painted in a wet-in-wet technique showing fast brushstrokes.

1 DRAW STRUCTURE. The drawing that I chose (top left) for my painting is one of many different approaches that I had considered for this cantilevered design. Sketching multiple ideas is always worth the time invested. The drawings that I reject now, but save for future consideration, may trigger just the idea that I will need on another day.

Tip
SCENIC CANTILEVERS

The great outdoors offers scenes with cantilevered patterns. Consider painting rocks jutting out from an anchoring beach with figures or birds on the rocks as the focal point. Another idea might be to paint the projecting form of a lighthouse anchored to land or rocks beneath it.

2 PALETTE PREVIEW. By testing color mixtures on the same kind of watercolor paper that I'll use for my painting, but in a larger size (22 × 15"), I have enough space to try a range of possible mixes and values. My chosen colors are ultramarine blue, cadmium yellow light, and cadmium red light.

BELOW **3** TRANSFER DRAWING, APPLY FIRST WASHES. Using a light box, I transferred my sketch to watercolor paper with a pencil. Then I placed the paper on a dry towel, wet the entire paper surface with a brush until it was evenly saturated, and applied the first washes. To control those washes so they would stay where I put them, I cleared my brush of excess water by patting it on a tissue before I picked up the paint. As the paper dried, it was easier to get the more definite edges of the roofs and rocks. I let the paper dry thoroughly.

4 REWET PAPER, DEVELOP SUBJECT. Since I would continue working with wet-in-wet brushstrokes, I ran water evenly over the entire front and back of my paper under a faucet. Soaking watercolor paper this way does not damage previous layers of dry paint. With excess water shaken off, I placed the paper on a towel again to saturate it evenly. I used brushes of several sizes to paint the trees, cottages, water, and walls along the shore, and then studied the painting while it dried. I decided to lighten a roof by lifting some color with a stiff brush. Then I pushed the dry, disturbed fibers down with the back of my fingernail.

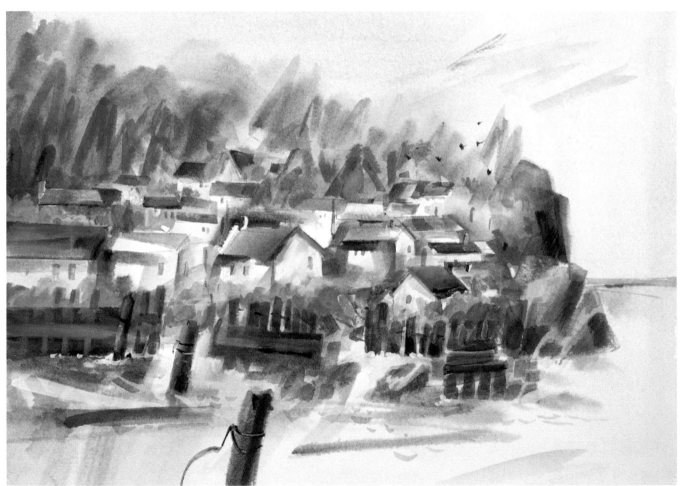

Marianne Brown, MAINE COAST, watercolor on 140-lb cold-pressed paper, 11 × 15" (28 × 38 cm).

5 FINAL TOUCHES. I wet my painting again under the faucet, and adjusted values of the green brushstrokes defining trees, then completed the docks, water, and birds. But now, the roof at far left seemed too lined up with the one next to it, so I painted a new roof there and added the light value and shadow below it. The cottages along the inlet provide the center of interest, and the birds help move the eye across the paper. The cantilevered design is completed with the anchoring trees at the left edge and the projecting group of houses.

other ideas to consider

Try something new in a cantilevered design by arbitrarily forcing the anchor and the projecting structure out of balance. Try using lighter colors in one area and darker colors in the other. You could bring balance back to the work by adding detail, line, contrast, repeated color, or by leaving white paper. Another idea: When the projecting symbol or subject is cantilevered from the sides, bottom, top, or corners, the background may anchor the projecting shape. Choose background values that suit your subject.

THINK OUTSIDE THE BOX

Invent a new plan. Anchor one simple shape, such as a square, on the left side of the paper and decide on the shapes, colors, and textures for the projecting shapes.

Can two or three things be cantilevered in the same painting? Do several cantilevered shapes need to attach to the same side of the paper, or can they project inward from any or all sides? Does the anchor need to be a big object? Can the anchor be a brightly colored small object that is balanced with a large, projecting area of duller values?

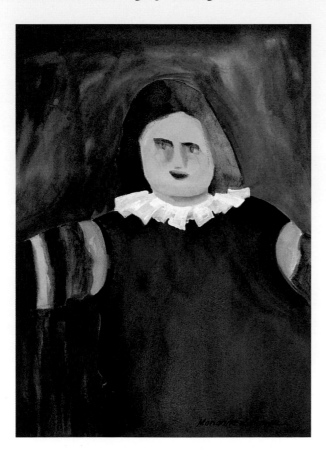

Marianne Brown, ALICE, watercolor on paper, 15 × 11" (38 × 28 cm).
This single figure, cantilevered from the bottom right corner, projects into the central area. For balance, the bright red background acts as the anchor.

ABOVE **Florie Baumann, DRIVING IN THE RAIN,** acrylic on paper, 15 × 22" (38 × 56 cm).

A rainy night, the back of an automobile, and the softened glare of oncoming headlights define the plan for this painting. Florie's many layers of acrylic paint regulate the subtle background values and textures. The outline of the cars and reflections on the wet road places the cantilevered shape at the bottom of the paper, with the background as the anchor of the design.

RIGHT **Lorna M. Mullick, HAMBURGER,** watercolor on paper, 7¹/₂ × 7¹/₂" (19 × 19 cm).

Almost tempting enough to eat! Lorna sketched her tasteful painting directly on watercolor paper. Her cantilevered subject projects from two sides of the paper. The background is the anchoring shape. This painting is a clear, beautifully painted rendition of a familiar subject.

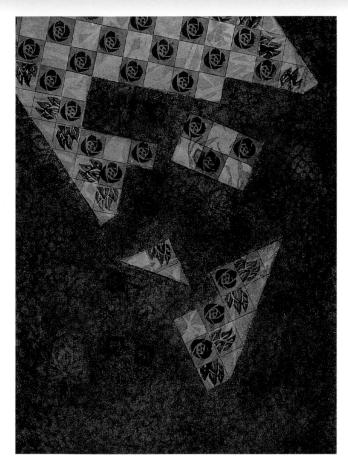

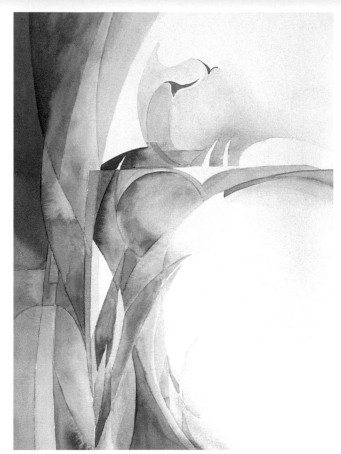

Joan Matsushima, LEAVING THE NEST, acrylic on paper, 15 × 11" (38 × 28 cm).
Joan applied and dried a thin coat of quinacridone gold on the entire sheet. Then she blocked out the anchoring shape and the projecting, floating shapes with cutouts from frisket paper (a self-sticking, transparent film that resists layers of paint). Her background colors are quinacridone crimson, magenta, and gold. She devised various textural effects using plastic wrap and paper doilies, which she sprayed with a mixture of gesso and water. The checkerboard squares were painted separately in the anchoring and projecting shapes and then printed with handmade carved stamps.

Jean Manty Bollinger, SPRING, watercolor on paper, 20 × 14" (51 × 26 cm).
Jean's delicate, abstracted study of land and sea is built on a cantilevered structure. The anchor shapes at the left describe foliage along the water's edge. Her impression of water and boats is projected to the right, completing the design. Wonderful rhythmic arcs and circles form shapes not usually associated with landscape paintings.

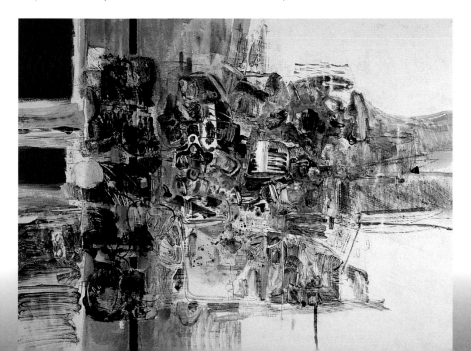

Marianne Brown, CACOPHONY, watercolor monotype with graphite powder on paper, 22 × 30" (56 × 76 cm).
I created this design with watercolor and monotype paints applied freely on a 1/8"-thick Plexiglas sheet, then dropped powdered graphite into the wet paint to add texture. When the paint dried, I printed the work on wet paper. Once that dried, I added detailed pencil lines and values. The strong contrasting colors on the left anchor and balance the more intricate detail in the projecting area of the design.

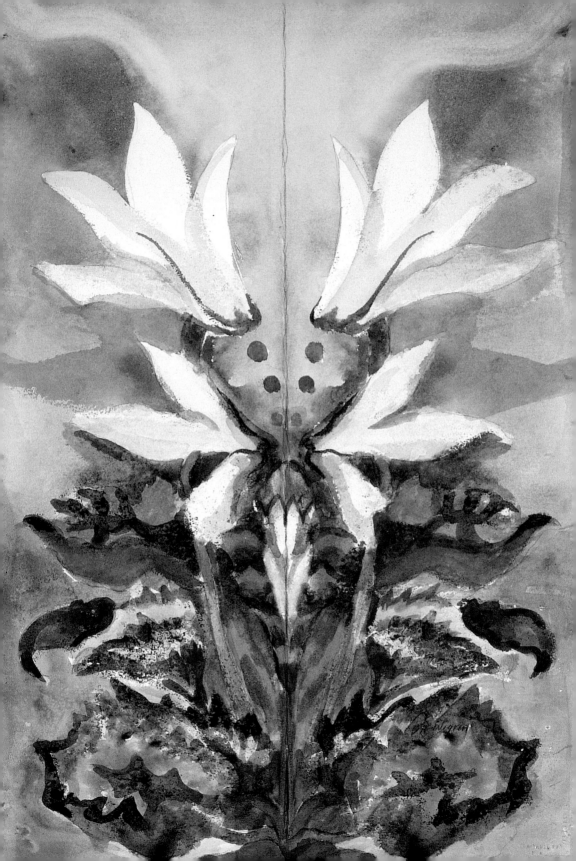

radial
DESIGN

A radial design is arranged as a structure with shapes branching out from a common center. The radiating shapes become the supporting design in the composition. The common center, the point of support, is the anchor for other shapes in the painting.

The most basic radial structure is a wagon wheel: its hub is the anchor, its spokes and spaces between them form the supporting design. The diagonal shapes lead the viewer's eye toward the center. In

BASIC RADIAL DESIGN
Construction-paper collage, 8 × 12" (21 × 31 cm).

planning a radial design for your watercolor painting, not all the surrounding shapes need to be diagonals. You can include secondary supporting shapes to direct the viewer's eye to other parts of your painting. The basic structure, however, should be built with diagonals and a point or shape as the anchor. Begin with familiar objects having a radial design: a daisy, an orange cut in half, an open umbrella. Build on the basic form with your own innovations. For example, if you start with the top of an open umbrella, try an unusual placement for it on your paper. Could it be at a slant? Could part of the umbrella be placed off the paper? Could the umbrella top be decorated with colorful designs? A kaleidoscope has an infinite variety of colorful radial patterns. Look to Mother Nature for sand dollars and starfish, arrangements of cut stones in a quarry, minerals and snowflakes. All offer inspiration for watercolor paintings based on radial design.

OPPOSITE Barbara Wigren, CYCLAMEN CYCLE II, watercolor on paper, 22 × 15" (56 × 28 cm).
Barbara began her radial design by folding dry paper down the center and painting on one side of the fold, then pressing the wet paint on the other half. In subsequent steps, she developed both halves. The radiating shapes lead to numerous points on the central axis, which also serves as the design's anchor in this painting depicting the life cycle of a cyclamen plant. The young plant's leaves are at the bottom; early buds come next; finally, at the top, we see the flower in full bloom.

CALIFORNIA FLOWER FIELDS

SUPPLIES

15 × 11" sketch paper

22 × 15" cold-pressed
watercolor paper

15 × 11" cold-pressed
watercolor paper

light box

masking tape

round brushes
nos. 6, 10, 12

nine tube watercolor paints

I decide to paint my impression of California flower fields as viewed from a hillside nearby. Several packing sheds surrounded by green grass will anchor the other fields and roads leading to the sheds. Bright, saturated color will emphasize the feeling of sunlight on the fields of flowers.

1 DRAW STRUCTURE. After making several sketches of my idea built around a radial structure, I narrowed it to these three, of which my favorite is the first (above left).

2 PALETTE PREVIEW. This sheet (22 × 15") shows the results of mixing pigments for the bright, colorful idea of flower fields in sunlight. My color scheme includes (from top left) cadmium yellow light, gamboges hue, and Indian yellow; (top center) red rose deep, cadmium red light, and burnt sienna; and (top right) cobalt blue, cerulean blue, and ultramarine blue. Normally, artists use combinations of values from light to dark for color variation in a painting. Here, my emphasis is on the most saturated pigment of each color.

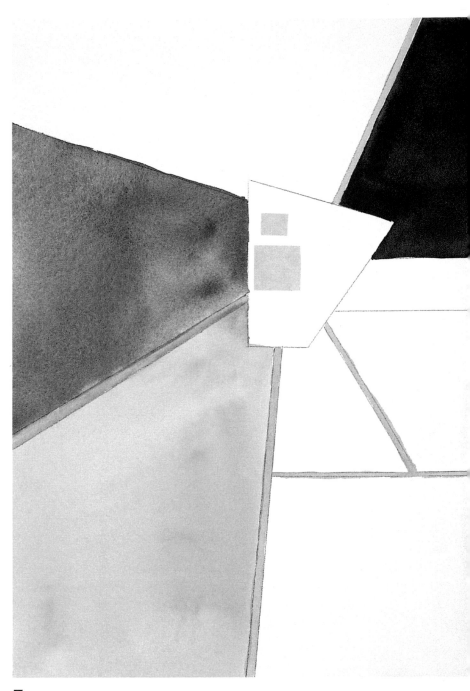

3 TRANSFER DRAWING, MASK, APPLY FIRST WASHES. I transferred the sketch to my watercolor paper using a light box. After clipping the paper to a board, I used masking tape as a block-out on the shed roofs in the central shape, pushing firmly on the edges of the tape so wet paint could not leak under it. I began painting each section by wetting the area first. To ensure that the colors would be clear, I used clean water and paint freshly squeezed from each tube.

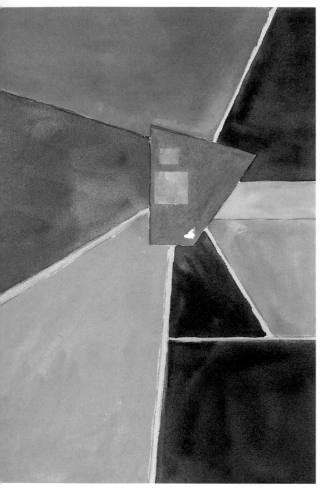

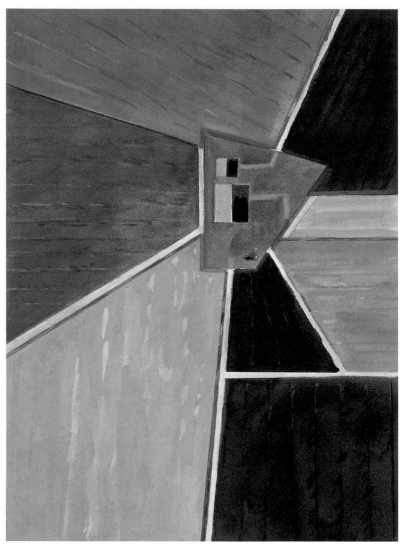

**4 APPLY REMAINING COLORS, CORRECT BUCK-
LING.** I painted the remaining colors to complete
the field shapes with irregular lines at their edges,
then intensified several colors and let the paint dry
naturally. At this point, the paper had buckled
because I had wet and dried each area separately.
To flatten the paper, I wet the back of it completely
and placed it facedown with a dry towel on top,
weighed between two clean, heavy boards, and let
it dry. (See "Tip" below for more about buckling.)

Marianne Brown, **CALIFORNIA FLOWER FIELDS,** watercolor on 140-lb cold-pressed paper,
15 × 11" (38 × 28 cm).

5 FINAL TOUCHES. I added bits of green to suggest grass along the road line in
the field sections and to echo the color of the central green shape. After removing
the masking tape, I painted the detail in the central anchoring area and added
dry brushstrokes for texture to signify rows of flowers in the field shapes. Then I
taped and lifted color for the main road lines to complete my radial design.

Tip
HOW TO FLATTEN A BUCKLED PAINTING

Place your painting facedown on a dry towel. Wet the back of the paper with a wash brush and clean water until it is evenly saturated.
Have two clean boards, larger than your painting, ready. Place the wet painting facedown on one of the boards. Cover it with a dry towel
to absorb the water. Put the second board (add books for extra weight) on top of the towel to keep it flat. Change the damp towel for
a dry towel until the paper is dry. If the paper isn't completely dry, it may buckle again. Check it by touching it with the side of your hand.
It will feel cool if the paper is not completely dry. If needed, repeat this procedure. A faster drying time is achieved by stapling the
saturated paper (face up) to a board (if you don't mind staple holes). Place the staples an inch apart, and keep the paper flat until dry.

other ideas to consider

Think about radial designs that incorporate shoes, pencils, kitchen utensils, bottles, flags, landscapes, seascapes, buildings, birds, animals—anything you wish to paint. Just remember to direct supporting elements toward a definite object, shape, or color. Human figures can also be the anchor in a radial painting, with other objects directed toward the figure. If you tend toward an abstract or nonobjective style, radial design is an excellent motif for structuring all the interesting shapes, colors, and textures that you can dream up for your painting.

THINK OUTSIDE THE BOX

Consider your sketches. Does your design show more distance when the anchoring point is not in the center of your paper? Can the anchor be outside the picture plane? In terms of composition, you do not have to point shapes or objects directly at the anchor; they can lead toward it.

ASSORTED SHAPES

If you throw a stone in a lake, do the concentric, circular ripples forming on the water express a radial design? Both round and straight lines abound in nature for your use as design references. Think about adapting straight-sided shapes and curved shapes in varied or alternating sizes.

TRY UNUSUAL COLORS, VARIED BRUSHES

Try colors that you seldom use. They might give new dimension to a radial design. Explore mixtures that you've never tried before, even if you think they won't work. Maybe they will! Experiment with brushes that you rarely pick up. Work with an assortment of brushes to remind you that variation is important in a painting.

radial designs

Pat Perry, FRED, watercolor monotype on paper, 11 × 9" (28 × 23 cm).

The diagonals and radiating brushstrokes set up the radial design in this monotype print. Pat used water sparingly to achieve the saturated color that printed so beautifully on her wet watercolor paper. Her overlapping brushstrokes define the texture of the feathers. She painted various mixtures of brown, yellow, red, black, and white on the monotype plate and let them dry before making this print.

Charlotte Morris, TIGER HILLS, watercolor on paper, 11 × 15" (28 × 38 cm).

Charlotte applied Prussian blue, cadmium yellow light, and burnt sienna on dry paper. She used smaller shapes in the foreground and larger ones in the background to form hills in this unique presentation of a landscape. The alternating values of warm and cool colors show a pleasing and innovative set of radiating rhythms that express the artist's personal inner vision.

Gisela Volkmer, CIRCUS, watercolor on paper, 15 × 20" (36 × 51 cm).

Gisela began her representation of a circus ring by wetting the paper first and letting the water soak into the paper's fibers for several minutes before applying paint. The soft edges of the colors were easy to control because the paper was evenly saturated. The light colors in the radiating spot direct the viewer to the distant circus ring, and presents a misty view of the performers from the top seats in the tent. The diffused light and diagonals give depth to this radial design.

ABOVE **Marianne Brown, MARINA,** watercolor, ink, and salt on paper, 20 × 30" (51 × 76 cm).

This painting applies the radial design in a different way, with the anchoring point located off the page. I used masking tape around every shape, a ruling pen for the lines, and table salt for texture on wet washes in some areas. Although I had no preconceived idea for this nonobjective painting, I gave it its title because the finished work reminded me of piers at a boat dock.

RIGHT **Amy Sum, PEACOCK'S GLORY,** watercolor on paper, 10 × 10" (25 × 25 cm).

This painting was drawn with a black Sharpie pen and painted on dry paper. The radiating tail feathers are designed in a completed circle with a wonderful array of blues, yellows, reds, greens, and violets. Amy's idea of containing her peacock in a sphere with radiating lines presents a peaceful mood.

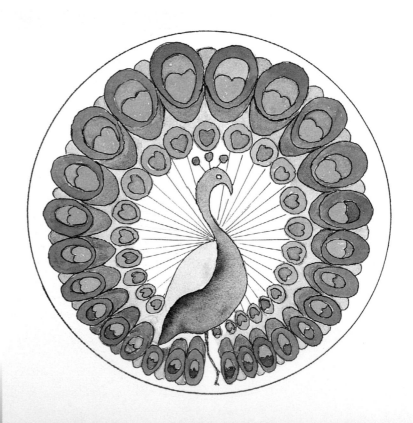

ABOVE **Berna Rasmussen, ROW, ROW YOUR BOAT,** watercolor on paper, 15 × 22" (38 × 56 cm).

An aerial view of rowboats inspired this radial design. Berna placed her dock at upper left as the anchor—literally and figuratively—of her well-balanced composition. She sketched her subject on smooth, hot-pressed paper and painted the boats individually.

LEFT **Marianne Brown, BIG SUR,** watercolor on paper, 22 × 30" (56 × 76 cm).

Majestic cliffs along the central California coast entice many artists to the Big Sur area in search of inspirational subject matter. The colors and shapes in this watercolor are abstracted to report my warm interpretation of the scene. The diagonal and horizontal forms lead to the anchoring light area with the collection of small shapes.

15
OVERALL DESIGN

There are two basic ways to construct an overall-pattern design: with an undivided surface or with a divided surface. Although most of the examples in this chapter take an abstract or nonobjective approach, realistic watercolor paintings can also be designed with an overall pattern of either type.

The undivided surface, also known as color-field painting, shows flat, shallow space. Usually based on close color values, the work has evenly repeated textures and colors that are unified by the flatness

OVERALL-PATTERN DESIGN
Construction-paper collage, 8 × 12" (21 × 31 cm).

of the design. The shapes may be separate, may touch each other, or may overlap. In terms of subject matter for this approach, think about familiar objects that are massed together in patterns. For example, look down at a basket of buttons, colored beans in a jar, a bowl of cooked spaghetti, or a box of paint tubes. Nature also offers undivided color-field patterns, such as a field of grass, wind rippling the surface of a lake, or rain falling on a window.

With a divided pattern, also known as a serial painting, the design is based on repeated shapes. Imagine a checkerboard grid that has an × in each square; the squares are all the same size and are repeated evenly over the whole painting. If your style is realistic, consider painting an open carton of eggs, an open box of chocolates, or a crate of boxed blueberries as viewed from the top. In each case, the grid will hold all of the parts together in a unified serial painting.

OPPOSITE Pat Pomidor, GLASS BEACH, watercolor on paper, 11 × 15" (28 × 38 cm).
Numerous pieces of smooth glass washed up on a beach were a perfect choice for Pat's undivided overall pattern. Both the colors and variety of these found treasures translate beautifully into the bright, clear, watercolor washes that she chose for her painting. For texture, she enhanced some areas with table salt sprinkled on wet washes.

TUCSON SUMMER

I decide to use gouache instead of transparent watercolor for this painting. Gouache is an opaque water-based medium. For light-valued washes, I add more water to the paint; for darker values, less water. Instead of working with brushes, I will stamp the paint with Styrofoam "popcorn" (packaging material) to build layers of paint for this color-field design. One of these stamps is shaped like a figure 8; the other, the letter O.

1 DRAW STRUCTURE. My preliminary sketches include both divided and undivided patterns. Of the many drawings I made, I decided to go with the undivided surface of the first drawing (above) as the model on which to build a color-field painting.

LEFT **2** PALETTE PREVIEW. On the larger (22 × 15") watercolor sheet, which gives me lots of room for experimentation, I try many mixtures of my chosen gouache colors (from top left), cobalt blue, yellow medium, red, and red rose. You will see white added as a fifth gouache paint as the work develops. The white gouache is stamped on the pattern to add a contrast to the other bright colors. Gouache paint needs to be thinned when using it with transparent watercolor.

3 STAMP FIRST COLORS. I placed my water-color paper (11 × 11") on a clean board, with my sketch nearby for reference. (I do not trace my sketch, as in previous demonstrations, because numerous overlays would cover the sketch.) For the first colors, I dipped a piece of Styrofoam shaped like the figure 8 into puddles of yellow and blue and printed them on the dry paper. (I always wash and dry the Styrofoam before dipping it in another color.) I let those colors dry before going on to the next step.

4 ADD MORE IMPRINTS. I continued stamping with both the figure-8 and letter-O Styrofoam shapes., making sure each color was dry before stamping on top of it. I added the red and red-rose gouache and balanced them in my composition.

Tip
TEXTURAL TOOLS

In addition to Styrofoam stamps, experiment with salt, plastic wrap, sticks, or any favorite item that you can dream up for creating textural effects. Another idea: Use acrylic matte medium to glue crinkled tissue or rice paper on your watercolor paper. When paint is applied to these glued papers, it creates a textured, overall flat pattern.

Marianne Brown, **TUCSON SUMMER,** gouache on 140-lb hot-pressed paper, 11 × 11" (28 × 28 cm).

5 FINAL TOUCHES. I continued by stamping white gouache with the letter-O shape to introduce some contrast. I alternated stamping the white with the other colors until the pattern was uniform. The completed painting is flat, balanced, and shows a predominance of middle values.

other ideas to consider

Experiment with using something other than a pencil or pen for making space divisions in your serial overall design. Oil pastels, crayons, thin masking tape, masking fluid, or white glue can all be applied on dry paper to form space divisions. Any of those tools will repel watercolor paint and show the grid lines. India ink or a Sharpie pen line also will show through watercolor paint as grid lines.

THINK OUTSIDE THE BOX

For an undivided pattern—a color-field painting—choose ideas or combine a few from the following guidelines: Vary the background color and/or color of shapes or objects; mix the sizes of objects, shapes, and lines; use different brushes and kinds of brushstrokes; sketch and overlap unusual shapes or objects so they fill the paper.

For a divided pattern—a serial painting—consider these ideas: Sketch ovals, circles, rectangles, or triangles in the overall grid; paint with only one or two colors and their values; paint with many colors and contrasts; place a new pattern in one part of the painting; change the size of the grid in one part of the painting; place a different subject, shape, color, or texture in each space division; double or triple grid lines.

COLLAGE COORDINATES

If you choose to base an overall design on collage art, cut or tear similar shapes and colors from old paintings to form the shapes. Find papers with close values. Contrasting values and/or colors also work well in a collage, as long as they are balanced.

overall designs

Barbara Falconer, CIRCLE'S EDGE, watercolor monotype print paper, 11 × 15" (28 × 38 cm).

Barbara employed three plates in making this monotype print, spraying water on her printing paper between stages. She painted the first with gamboge hue and let it dry. On top of that, she stamped permanent red, using large bubble wrap for texture, and let that dry. For her third, smaller plate she used thalo blue, stamped on with a small bubble wrap for texture. Finally, she glued on pieces of paper to add other shapes to her color-field design.

Pamela Miller, FLUTTER BY, watercolor on paper, 15 × 22" (38 × 56 cm).

Circles, squares, and diagonals are cleverly interwoven in this overall color-field pattern. Pamela's well-balanced distribution of the geometric shapes and soft colors brings a sense of cohesion to her intricate painting.

Anne Fallin, BLUE CHAIRS, watercolor on paper, 16 × 20" (41 × 51).

This painting displays an innovative approach to a color-field overall pattern. Anne was inspired by a five-hundred-year-old cottage in Sweden, which was filled with chairs, tables, rugs, paintings, cloths, and plants that seemed to be dancing around the room. She set out to demonstrate that feeling in her painting, and achieved it by planning space divisions that move her subjects across her composition in an animated manner.

Marianne Brown, ARBOREAL, watercolor on paper, 12 × 16" (31 × 41 cm).

For these abstracted trees, I used straight-sided shapes to depict the trunks and curved shapes for the foliage. The idea was to balance the colors and values and leave white paper for contrast. I added some overlapping lines to suggest branches, and unified the composition by using flat color patterns with dominant hard edges. Although this is another example of a color-field overall pattern, this time, the shapes are unequal and the painting has a wide range of values.

Marianne Brown, NIGHT LIGHTS, gouache on paper, 11 × 11" (28 × 28 cm).

For this color-field overall pattern, I layered and stamped gouache on dry paper, letting each layer dry before applying the next. Using a piece of squared Styrofoam, I stamped unevenly each time to build a slightly varied texture. For added variety, I left some parts of the previous layers unstamped and allowed them to show through as part of the design.

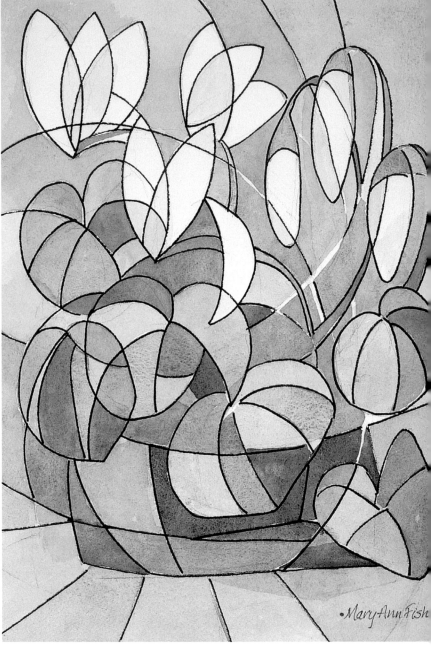

Mary Ann Fisher, CYCLAMEN V, watercolor and pen on paper, 15 × 11" (38 × 28 cm).
Mary Ann's abstracted cyclamen is designed with curved space divisions that are in keeping with the shapes of the plant. The divisions are random and close to the same size each time, and the colors are close to the same value. This color-field pattern succeeds through its use of similar shapes and close color values.

Amy Sum, STACKING UP, watercolor on paper, 11 × 11" (28 × 28 cm).

Amy created her divided-pattern serial painting with cobalt blue, cadmium orange, and aureolin yellow, applying each color separately on dry paper. By placing the diamond shapes in front of the stripes, she succeeded in giving her crisp painting a three-dimensional quality.

Marianne Brown, SUE'S QUILT, watercolor collage on paper, 18 × 18" (46 × 46 cm).

First, I measured and drew the outside dimensions of my collage and grid on the watercolor backing paper. Next, I painted each color on a different piece of watercolor paper. When they were dry, I drew the same sized squares on the back of each one, and cut out the triangular shapes needed for the collage. I glued them in place to complete my divided serial-style collage.

THiz iz HEiDi
4-83

16

floating
DESIGN

When you paint a subject using floating shapes as your basic design, the floating shapes should dominate the composition, but other shapes may be introduced to enhance your painting. There are many ways to approach a floating design. You might start with varied floating lines, overlapping floating shapes, or a single floating shape. The shapes may be angular or curvilinear or a combination of the two. The background may be of a light, medium, or dark value, depending on your subject matter, and it can be

BASIC FLOATING-SHAPES DESIGN
Construction-paper collage, 8 × 12" (21 × 31 cm).

plain or busy. Clear, bright colors might float forward while duller or mixed colors might recede. As a general rule, larger shapes seem to float forward more than smaller ones.

You might decide to confine your design to varied kinds of lines that float on your paper. Floating lines can form an even or uneven overall pattern. Objects can be made to float by contrasting colors and values, by having no horizon line, or by the position of the shapes on your paper. Another approach is showing how light and shadow affect the shapes that float. What about choosing a truly unusual setting for your subject, such as having a still-life setup float in the sky?

Many realistic objects can float in a composition. Boats float on a lake, clouds float in the sky, fish and seaweed float in the water, pieces of fabric may float on a table. Objects on a beach can be seen as floating on wet sand. Kites float. Balloons float. A group of paintings on a wall might be arranged to float.

OPPOSITE Daisy Hyer, THIS IS HEIDI, watercolor on paper, 22 × 15" (56 × 38 cm).
Daisy found this child to be so vivacious that she could not capture the spirit of her lively personality in a conventional, single portrait. She solved the problem by using floating shapes to show the little girl's many expressions. Using a glazing technique, she built up her layers of paint into a successful, charming, and innovative multi-portrait watercolor.

ABIQUIU WALL II

SUPPLIES

11 × 15" sketch paper

22 × 15" hot-pressed watercolor paper

11 × 15" hot-pressed watercolor paper

light box

pencil

watercolor pencils

fine Sharpie pen

round brushes nos. 6 and 14

bath towel

three tube watercolor paints

While on a trip to New Mexico, I was excited to see an old adobe wall with a multitude of dark scratch marks on its surface. Many old walls had fascinated me in the past, but this one seemed extra-special. I still can't imagine what type of tool was used to produce so many dark lines during the building of the wall. Despite its mystery (or maybe because of it?), I decided to use the wall as the subject for a painting. My plan is to paint an interpretation of the wall, using the natural, sand-colored pigments as a background, with bright, reflected colors from a nearby clothesline as floating shapes.

1 DRAW STRUCTURE. The basic structure of this painting could be one floating shape or a series of floating shapes. After trying both methods in a number of different sketches, I narrowed my choices to these three. On further reflection, the first sketch (top left) seemed to offer the best space divisions for realizing my idea.

Tip
VARIED ANGLES

Consider turning your floating-shapes design at different angles. Do the area and shape of the background work better with the floating elements in a different position? Make rough sketches with pastels or crayons to see how colors work when shapes float at different angles.

3 TRANSFER DRAWING, APPLY FIRST WASHES. With the aid of my light box, I transferred my drawing to watercolor paper, using a pencil to trace some of the scratch marks and a pen for others. After placing the paper on a dry towel, I wet the paper evenly with my no. 14 brush and painted the background washes in light values of the three colors. Next, I painted and balanced the colors for the floating shapes, and let the paper dry naturally.

2 PALETTE PREVIEW. Using the larger watercolor paper (22 × 15") for experimentation, here are many possibilities that result from mixing (from top left) cobalt blue, raw sienna, and cadmium red light. Referring to this sheet as I paint reminds me of my options for the variations I will need to include in depicting the reflected floating shapes on the wall.

4 ADJUST COLORS, DEFINE SHAPES. When the paper was dry, I placed it on the towel again and began to adjust the values on the dry paper by brightening some areas and dulling others with complementary colors. I was also able to define the floating shapes more clearly, using the fine point of my no. 6 brush. I kept the edges of the shapes soft by putting clear water around the new brushstrokes. After the paper had dried, it was time to stop and study the painting.

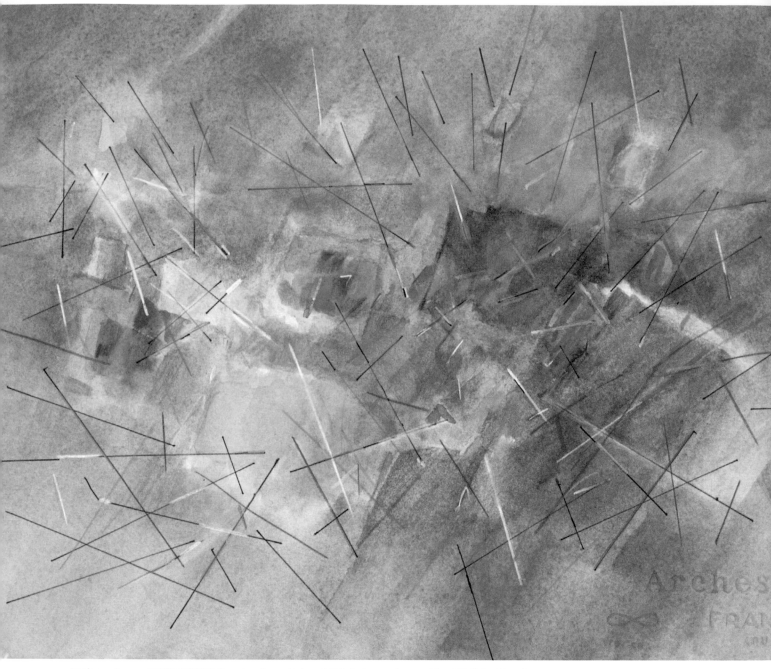

Marianne Brown, ABIQUIU WALL II, watercolor and ink on 140-lb hot-pressed paper, 11 × 15" (28 × 38 cm).

5 FINAL TOUCHES. I realized that the floating colors were too bright, with too much contrast between them and the background wall. To show the warm color of the adobe wall, I changed the top area to a darker value and added more warm color in the foreground. Then I dulled the colors that define the floating shapes, added more dark scratch marks, and changed some of their colors by using watercolor pencils on top of the lines. Now the painting displays the color of the adobe wall. Soft edges are dominant. Some hard edges appear for contrast. The colored shapes float in the composition. The completed painting is true to my original idea.

other ideas to consider

Dream up new ways to arrange subjects. Draw one object floating inside another. Overlap floating subjects. Alternate curved and straight-sided shapes. Draw all shapes the same size. Paint all subjects or shapes the same color. Try making every shape or object float off the edges of the paper.

THINK OUTSIDE THE BOX

Experiment with very bright colors and grayed colors and with light, medium, and dark values for contrast and variation in your painting. What happens if you paint larger shapes with receding colors and smaller shapes with bright, eye-catching colors?

GEOMETRIC SHAPES

Those of us who usually take an abstract or nonobjective approach to painting can use floating geometric shapes. You can start with a simple square, a rectangle, a triangle, a circle, or a cone. When designing floating geometric shapes, change sizes and colors, overlap some, and use line and texture for variation.

ORGANIC AND FANCIFUL FORMS

Shapes that are more organic or curved seem to float particularly well on a square or rectangular picture plane, because they do not relate to the straight-sided edges of the paper. Remember, you can also make up your own fanciful shapes or symbols to use for a floating design. Always consider size, shape, color, value, line, and texture for variation in your plan.

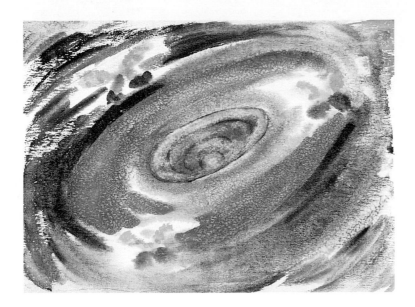

Jo Scherrer, INFINITY,
watercolor on paper, 11 × 15"
(28 × 38 cm).

Here is a good example of how fast brushstrokes can establish the mood of a painting. In this case, Jo's aim was to give her picture an outer-space feeling, which she certainly accomplished with her brushstrokes that seem to be spinning and floating. Her colors are clear and bright. As she applied them on dry paper, the strokes ran together, creating the soft edges.

floating designs

Betty Vanden Heuval, SEASIDE, watercolor and collage on paper, 15 × 22" (38 × 56 cm).

Betty cut and painted floating shapes to form the fantastic sea creatures and plants depicted in her very personal, abstracted approach to an underwater scene. The density of the overlapping forms also contributes to a sense of deep-sea life.

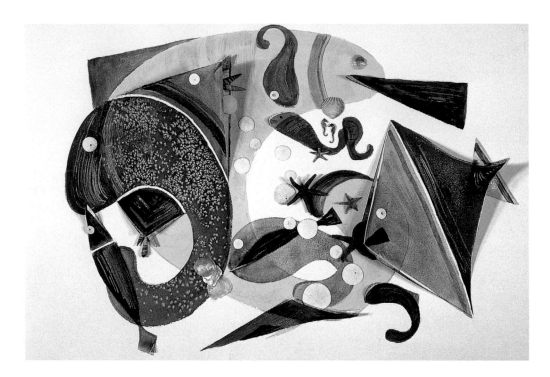

Helen Richards, FIND HELEN, watercolor on paper, 11 × 15" (28 × 38 cm).

Helen's imaginative design is based on hidden letters of her name. Her palette of reds, gamboge hue, and the white of the paper against a black background makes the strong, overlapping angular shapes pop forward. She used masking tape around each shape to aid in painting their hard edges. For the textural effects, she used stamps made of cardboard, printed on as the final touch to her fine floating-shapes design.

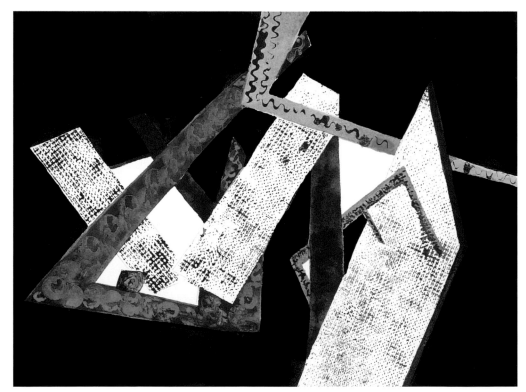

Jenifer Kolkhorst, BALLYHOO, watercolor on paper, 15 × 22" (38 × 56 cm).
Jenifer actually used a real fish as a tool for this painting. After drying its scales with paper towels, she applied paint right on the fish, which she then stamped on dry paper. She repeated the process three times to create her fish trio. Their bright colors and good contrasts add to the action of fish floating and cavorting on the paper.

Sally Bellenger, FOREVER MAY SHE WAVE, watercolor on paper, 11 × 15" (28 × 38 cm).
Because this flag seems to be flying, it qualifies as a floating shape. Sally mixed her alizarin crimson and ultramarine blue on the paper, which gives those color washes their brightness and range of values. The curving rhythms are emphasized further by the white of the paper that forms the stars and stripes.

Marge Long, JUSTICE, watercolor on paper, 11 × 15" (29 × 38 cm).
These geometric shapes float close together in a painting that has a good plan of dark and light values. Marge's cool colors are dominant, with some parts of her composition left unpainted to coordinate and balance with the background shape. The result is a cool, organized, and varied floating-shapes pattern.

Helen Delfani, ENIGMA, watercolor monotype on paper, 10 × 14" (26 × 36 cm).

Helen's large, single shape encloses several smaller ones that display a variety of interesting textures. By having the assembled shapes float, rather than anchoring the unit up to the edges of her paper, she draws and holds the viewer's eye on the center of interest in her painting.

Norma Werner, PAINT POTS 5, watercolor on paper, 22 × 17" (56 × 43 cm).

Norma's plan was to capture the colorful pots her husband used for mixing his oil paints, and their casual, random placement. She added other items to vary the shapes and sizes of the containers in her floating-shapes painting. The arrangement leads the viewer's eye along a curved path ending at the turpentine can. Fine planning shows a good combination of warm and cool color painted directly on the paper to produce a compatible color scheme.

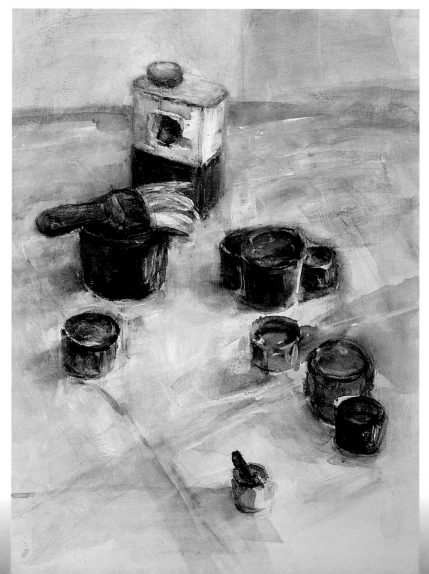

final thoughts

As you learn and practice all the design motifs in this book, they become part of the creative process you use to compose all of your paintings. The best part of the procedure comes when you realize that areas in your work need to be removed, changed, repeated, or balanced in order to build a better composition. By combining design concepts—while letting one design concept be dominant—and trying new shapes, lines, textures, and color combinations, you can develop your own personal style. Good luck!

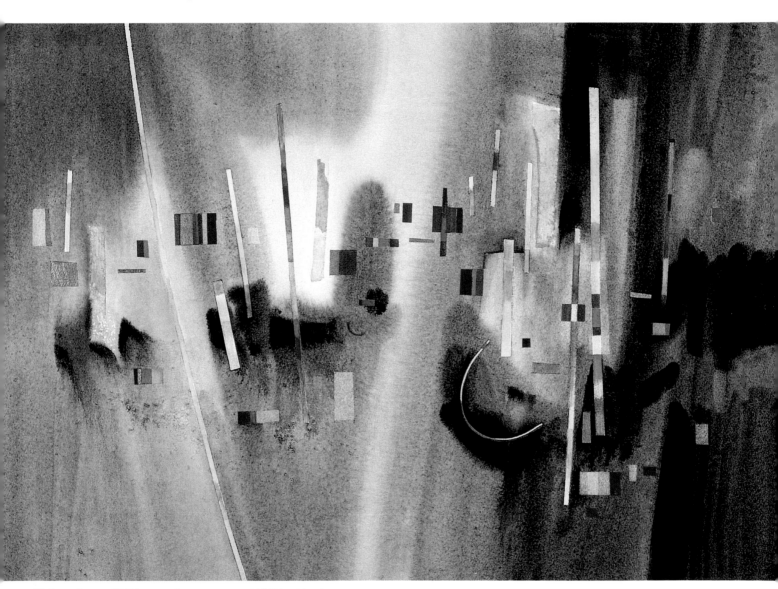

Marianne Brown, NEON, watercolor on paper, 15 × 22" (38 × 56 cm).
I wanted to present floating lines in a painting, and decided that depicting neon lights, flashing in the dark night, would be the way to do it. I blocked out some lines with tape to suggest the neon, and used a varied background wash of Payne's gray. Further taping followed, to aid in lifting additional floating lines with a stiff, wet brush. I painted the bright colors last on my white paper, where tape and lifts had been placed.

index